Arthur Dreyfus

DEFINING DRESSES

A CENTURY OF FASHION

 LES ARTS DECORATIFS Flammarion

Art Direction and Layout Design:
Philippe Apeloig, assisted by
Yannick James
Quotation Research:
Julien Vandenbroucque

English-language edition
Editorial Director:
Kate Mascaro
Editor:
Helen Adedotun
Translated from the French by
Alexandra Keens
Copyediting:
Lindsay Porter
Typesetting:
Gravemaker+Scott
Proofreading:
Samuel Wythe
Cover Design:
Studio Flammarion

Color Separation:
Arciel Graphic, Paris
Printed in China by
Toppan Leefung

Simultaneously published
in French as *101 Robes*
© Flammarion, S.A., Paris, 2015
© Les Arts Décoratifs, Paris,
2015

English-language edition
© Flammarion, S.A., Paris, 2015
© Les Arts Décoratifs, Paris,
2015

15 16 17 3 2 1

ISBN: 978-2-08-020225-3

Dépôt légal: 09/2015

This is a dress-book of many
threads and colors.
It owes its existence to
the following people, who
I wish to thank sincerely.

At Flammarion:
Teresa Cremisi,
Sophie Laporte,
Camille Giordano,
Julien Vandenbroucque,
Cécile Frappé,
Maïwenn Pellerin,
Sylvie Bellu,
Kate Mascaro,
Helen Adedotun,
Élodie Conjat,
Patrizia Tardito d'Arciel,
and Guillaume Robert.

At the Studio Apeloig:
Philippe Apeloig,
Yannick James,
Léo Grunstein,
Benedikt Eisenhardt,
and Diariatou Sarr.

At the Musée
des Arts Décoratifs:
Olivier Gabet,
Marie-Sophie
Carron de la Carrière,
Emmanuelle Beuvin,
Marie-Pierre Ribère,
Marie-Hélène Poix,
and all of the documentation
teams.

And finally, many thanks
to my precious characters:

Pierre Barillet,
Pablo Marcus Bien,
Adrien Blondel,
Carla Bruni,
Caroline Champetier,
Denis D'Arcangelo,
Aliénor Dreyfus,
Bernard Dujourdy,
David Dumortier,
Nicolas d'Estienne d'Orves,
Françoise Fabian,
Laure Fournis
Élodie Frégé,
Ines de la Fressange,

Andy Gillet,
Adrien Goetz,
Jean-Paul Goude,
Bettina Graziani,
Edouardo Guelfenbein,
Stéphane Guérin,
Ingrid-Mery Haziot,
Guillaume Henry,
Noël Herpe,
Henriette Jansen,
Émile Janvier,
Isabelle Kauffmann,
Jean Kauffmann,
Sévane Kauffmann,
Daniel Kenigsberg,
Vénus Khoury-Ghata,
Robert Kopp,
Christian Lacroix,
Eugénie Lemoine-Luccioni,
Gilles Leroy,
José Lévy,
Peter Lindbergh,
Didier Ludot,
Ronan Martin,
Patrick Mauriès,
Sébastien Meyer,
Brice Michelini,
Dominique Michelini,
Patrice Michelini,
Bill Miglore,
Yann Moix,
Kate Moran,
Gwenaël Moysan,
Olivier Nicklaus,
Dominique Noguez,
Amélie Nothomb,
Pierre Notte,
Roland Oberlin,
Marie-Louise Pothus,
Olivier Py,
Maroussia Rebecq,
Jérôme Réveillère,
Phil Richardson,
Angelo Rinaldi,
Anna Rios-Bordes,
Olivier Saillard,
Jean du Sartel,
Kahina Selmouni,
Mathieu Simonet,
Eric Slabiak,
Alix Thomsen,
Arnaud Vaillant,
Alexis Vincent,
and one hundred
passing voices.

Foreword
The Dress Addressed

There are innumerable ways to talk about fashion—as many as there are dresses.

The 202 "sartorial fragments" skirting around the notion of the dress were personally selected by Arthur Dreyfus. Eluding historical convention and shunning banality, Arthur prefers to venture into other dimensions, exploring inner paths where one can lose oneself and begin to dream and get in touch with one's perceptions. Abstractions become insights and a cast list of familiar characters brings ideas to life on the pages that follow—the vintage-clothing specialist, the curator, the model, and the poet, to name but a few. Arthur stage-directs them all, having them take their cues from one another, as in the witty dialogue from a classical play or a screwball comedy of the 1930s or '40s. Each dress featured represents a different year, illustrated by quotations from the period, shedding light on subtle evolutions in artistic taste and literary style: whether brilliant, radical, deliciously dated, or slightly complicated, from Madeleine Vionnet to Martin Margiela, and from Gertrude Stein to Carmel Snow. The only guiding principle governing these pages is freedom.

However, Arthur's most remarkable choice was to draw all 101 dresses from the exceptional collections of Paris's Musée des Arts Décoratifs, including the museum's historical collection, enriched yearly by its discerning acquisitions policy, and from the unique collection of the Union Française des Arts du Costume (UFAC), headed by Pierre Bergé. As a major national fashion archive, the Arts Décoratifs has for many years been responsible for preserving, enhancing, and disseminating the inestimable works of the UFAC. It strives to achieve this goal on a daily basis, ever in pursuit of the constantly evolving history of fashion. Working with the support and friendship of Marie-Sophie Carron de la Carrière, chief curator of the 1800–1939 Fashion and Textile collections, who also has expert knowledge of the 1980–2010 period, and with the active collaboration of Marie-Pierre Ribère, and in particular of Emmanuelle Beuvin, fashion librarian at the museum, Arthur has spent long and happy hours examining in detail hundreds of dresses held at the Arts Décoratifs, considering them in the light of his project as one would weigh the human soul, with rigor and with humanity. He has added to the chronological evidence that of words, and clad the bare bones of dates with the history of fashion: from 1915 to 2015, through 101 dresses.

Olivier Gabet,
Director of the Musées des Arts Décoratifs, Paris

First of all,
when
are they born?
When
do they live?
When
do they die?
With the first
sketch
or the last
fitting?
On the runway
or draped on
the bodies
of the women
who select them?
No sooner donned
than taken off,
forgotten at
the back of
a wardrobe, or
sent to a museum?

Christian Lacroix

202
SARTORIAL
FRAGMENTS

1 A dress is
a garment,
and a usage.

2 The earliest record of the word
"dress," in the sense of a woman's
garment, dates to the mid-
seventeenth century. The verbal
form, from the Middle English,
meaning "to put right" as well as "to
decorate" and "to put on clothing,"
goes back to the fourteenth century.
It originated from the Old French
dresser, meaning "to straighten"
(derived from the Latin *directus*)
and also "to dress" in the sense of
"put on clothing." The French prefer
the word *robe* for a woman's dress,
which derives from the Germanic
base *rauba*, and the verb "to rob"
(*rober* in the Old French, *dérober* in
its current form) and dates back to
the twelfth century. The reference
here is to plunder, the spoils of
war. So before it was a garment,
a *robe* was what you had taken
from the enemy.

3 THE VINTAGE-CLOTHING
SPECIALIST:
"A dress is a little
black dress."

4 Most dictionaries
describe a dress as an
item of outerwear, which
underlines a basic truth:
a dress is a garment that
can and wants to be seen.

5 THE VINTAGE-CLOTHING SPECIALIST:
"A black dress is a symbol
of elegance. A woman feels
comfortable in it, whether
she's beautiful or ugly, rich
or poor. It's both a weapon
and an armor."

6 THE WALTZER:
"To me, a dress
is a floral-print
dress."

7 Writing about dresses
is like a treasure hunt.
Everyone has their own
definition of a dress, and
each of them conjures up
a new imaginary world.

8 THE ACCOMPANIST:
"English girls all
know what an LBD
is: a little black dress.
But does a *PRN*
[*petite robe noire*]
mean anything to
French girls?"

9 THE DANDY:
"The little black dress
is pretty much
the woman's suit."

10 THE PSYCHOANALYST:
"A dress is a kind of
'rapture'—or rhapsody,
you might say—made of
pieces and parts that have
been 'seized' from here or
there. In the way it's put
together, it's always a kind
of stolen property."

11 THE VINTAGE-CLOTHING SPECIALIST:
"A woman enjoys a
sentimental relationship
with her black dress. She calls
it *my little black dress*; she
wouldn't say *my little yellow
dress* or *my little pink dress*."

12 THE POET:
"When you speak to me
of dresses, what I see
is always a stolen
moment—stolen from
the woman passing by.
You're snatching a piece
of her skin."

13 THE COLORIST:
"I wear the dresses of a friend
who died a year ago, so that
she lives on."

14 THE FASHION PHOTOGRAPHER:
"A woman in a skimpy,
see-through dress is
already 15 to 50 percent
of the way to saying *yes*."

15 THE COLORIST:
"There's the dress that you
know gets people looking
at you."

16 Wearing a dress is like
carrying a bunch of
flowers. Not just *wearing*
it: taking it with you,
leading it somewhere.

17 THE VINTAGE-CLOTHING SPECIALIST:
"All designers have to make their own version of the little black dress. It's the most difficult exercise, because it leaves no room for mediocrity and the slightest defect shows."

20 THE COLORIST:
"There are very beautiful dresses that make you feel very lonely."

21 Imagining the jealousy of billions of dresses put away, stored, hung on coat hangers, folded on shelves, waiting for their turn.

23 THE MUSE:
"When I was little, Walt Disney was the first designer to thrill me with his Snow White and Cinderella dresses."

24 THE ACTOR:
"My mother worked in a shop. When a lady told her that a dress was too tight, she'd walk round the shop and come back with the same item and ask, 'How about this one?' And the customer would take it."

26 THE ACCOMPANIST:
"In England there's an awful kind of dress: the one ladies wear on Sunday morning to go to church. It existed thirty years ago and it still exists today. It's a dress with tiny flowers all over it, made of a cheap material with a bodice that's too tight. It's worn by women who aren't used to dressing up to look attractive, but it's Sunday after all—an important day."

19 A dress that conceals a woman from head to toe—which adorns no single portion of her body—isn't a dress, or even a garment. As in a dialogue, it takes two faces to make a dress.

22 The mathematician develops an equation to determine the *probability that a given dress will be worn*:

(probability that the dress still fits)

×

(probability that it's the right season)

×

(1 – number of days it's already been worn)

×

(1 ÷ number of days the dress has existed; i.e. the age of the garment, which is increasingly likely to be hidden at the back of the closet behind new acquisitions)

+

(probability that the dress is back in fashion)

×

(probability that its owner remembers she has that dress)

×

(1 – probability that the dress is spoiled or that its owner dies)

25 A dress leans neither to the right nor to the left.

18 THE CURATOR:
"I'm not surprised by the etymology of the word *robe*. What better way to prove you've defeated an enemy than by wearing their clothes?"

27 "What does a dress mean to you?"
"That's a hard question. If I knew the answer I wouldn't be studying design."

28 Despite its infinite possible variations, a dress is an all-in-one: it's an idea, a movement, a stroke.

29 THE MATHEMATICIAN:
"Take a gathered dress: it's possible to describe its complexity in terms of a fractal. You can describe its air flow: for example, a short dress creates a turbulent flow whereas a long dress would tend to produce a laminar flow (the air slides along the fabric). But then I could also talk to you about sensual flow."

31 A dress is a discourse on form.

30 THE ARSÈNE LUPIN BUFF:
"Dresses are too often overlooked by art historians as a means to date a painting. Yet they sometimes enable you to estimate the year a portrait was executed. In the nineteenth century, it's even more precise; fashions changed twice a year."

32 THE DANDY:
"A wedding dress is the bravura piece that comes at the end of an haute couture show, and the master on that score is Lacroix."

33 THE GUITARIST:
"A wedding dress—overdone, too fussy, too voluminous—does absolutely nothing for me—but marriage isn't exciting either."

34 THE MOST PHOTOGRAPHED FRENCHWOMAN IN FRANCE:
"In those days, each dress was announced during a show. The models walked right by the people watching, everyone could touch the fabrics; there was an intimacy between the dress, the model, and the clients."

35 Even when they're spotted, one hundred and one dresses don't bark or fetch the ball.

36 THE POET:
"There's a poem by Malcolm de Chazal that goes, *All women cheat on their husbands with their dresses*. And that's a rather pleasing concept, because a dress does enable deception, through its forms, but at the same time it's very faithful, in that it envelops the woman's body all day long. There's many a man who'd like to be in the place of that dress."

37 Conceiving a dress as an open book: from Sonia Delaunay's "poem dresses" (printed with texts by Tristan Tzara, Blaise Cendrars) to Jean-Charles de Castelbajac's graffiti dresses (Guy de Maupassant, Jules-Amédée Barbey d'Aurevilly), or Yves Saint Laurent's "written" dresses (Jean Cocteau, Guillaume Apollinaire).

38 THE VINTAGE-CLOTHING SPECIALIST:
" A well-cut dress is a magical costume that conceals a woman's defects and enhances her charms."

39 A close encounter between a body and an object.

40 THE LITERATURE PROFESSOR:
"When you love painting, your mind is a bit distorted by Velázquez: women go to war, and their dresses are their armor."

41 THE COLORIST:
"To hide what needs to be hidden and enhance what must be enhanced: even with a dress, you need to know yourself."

42 A dress by any other name: the *scarlet robe*, redder than purple (even colors have their superlatives).

43 "How are you today?"
"If I find a dress, I'll be okay."

44 In every fairy tale and every dungeon, the evil woman and the innocent heroine both wear dresses.

45 THE ACTOR:
"When my mother wanted to sell a dress, she'd wear it. She was such a pretty woman that people were buying it from her all day long."

46 Have you heard that in the Middle Ages one of the most despicable, shaming dressing-downs for a courtesan was *to have the skirts of her dresses cut short*?

47 THE FASHION HISTORIAN:
"When I'm told that a dress took nine hundred hours of work and all I see is a vase, I consider that too long. They'd have done better to spend two minutes on it. Making a garment well is not a question of technique but of invention."

48 THE ACTOR:
"Where I come from, we didn't have dresses, we had frocks. You have to remember, I come from the sticks."

49 THE FILMMAKER:
"It reminds me of a Hans Christian Andersen tale, "The Emperor's New Clothes." It's about a vain and arrogant king who ends up parading naked before his court because two swindling weavers claim they have sewn him an oufit that is *visible only to those who are worthy*. No one—save a child in the end—will admit they can't see the clothes for fear of revealing themselves as inept. The message being that you should trust what you see, not what you're told."

50 *Unhook, take off, slip out of, buy, put together, copy, sew, cut, fold, crumple, cut out, fit*: the verbs of a dress.

51 THE BELGIAN–JAPANESE WRITER:
"Where did the notion that dresses should be a feminine thing come from? A man in a robe is magnificent. Trousers are an absurdity. Life is more beautiful in a dress. I am all for everyone wearing dresses. This is the only thing I'll take a political stand on."

52 THE VINTAGE-CLOTHING SPECIALIST:
"I have a Japanese client who regularly buys Chanel suits from me. He's a banker who dresses in women's clothes as soon as he's out of the office. Other women are quite jealous usually, because he has some very fine jewelry inherited from his mother, and he wears it well."

53 "Does a woman look good in a dress?"
"It depends on the woman, and on the dress."

54 THE POET:
"The great chagrin of my mother's life was that she wore the same dress to the ball for four years running, because she had no money. That was the worst sign of poverty there could be, because you only wore a dress once—twice at most (the second time you turned a blind eye)."

55 THE VINTAGE-CLOTHING SPECIALIST:
"If a client asks me for an *evening dress*, I throw her out. You don't say *an evening dress*, you say *an evening gown*."

56 Referring to two women, Claude Farrère christens one *the yellow dress* and the other *the green dress*. Edmond Rostand—speaking through Cyrano—confirms the effectiveness of the synecdoche where women and dresses are concerned: "Thanks to you there has passed across my life the rustle of a woman's gown."[1]

57 THE ACCOMPANIST:
"For me, the ideal dress is extremely long. Not necessarily wide like a meringue, but long. Men don't have the possibility of wearing something that elongates the body from top to bottom."

59 That dress I understand, that dress I don't understand.

58 "What poet would dare to distinguish between her and her apparel? Show me the man who, in the street, at the theatre, or in the Bois, has not enjoyed, in a wholly detached way, the sight of a beautifully composed attire, and has not carried away with him an image inseparable from the beauty of the woman wearing it, thus making of the two, the woman and the dress, an indivisible whole."[2] For Baudelaire, a man thinks of a woman dressed—he imagines her heels, her skirts, her dresses, her underwear, her jewelry; if he imagines her naked, it is because he has *undressed* her.

60 THE FRANCO-ITALIAN SUPERMODEL:
"A dress is made to be beautiful, but we prefer it to be comfortable."

61 THE VINTAGE-CLOTHING SPECIALIST:
"After wearing them once, some wealthy women would give their dresses to less well-off friends, or to cousins. That is why you find many Chanel and Courrèges dresses today that have been fiddled with and slightly altered."

62 Over the centuries, dresses have changed one hundred times less than the ways in which they've been presented, represented, staged, illuminated—photographed.

63 THE MUSE:
"Imagining it on, seeing it, possessing it, getting ready to wear it, accessorizing it, presenting it to an audience that may or may not be receptive, taking it off or having it removed by a gentleman, putting it away until its next appearance: I never tire of that ritual."

65 THE COLORIST:
"You can adapt a dress to your mood."

64 A horror story: the body of a woman is discovered many weeks after her death. Her extremely tight dress has sunk into her skin, making it impossible to separate flesh from fabric.

66 The knee-length dress. The long-sleeved dress. The ankle-length dress. The high-necked dress. The dress that stretches to the heavens.

67 THE DANDY:
"Keeping your mother's dresses is a bit *Psycho*."

68 THE VINTAGE-CLOTHING SPECIALIST:
"She didn't have her mother's chic. She was chubby, and she kept saying, *I've got to get rid of my mother's clothes because they're cluttering up my head.* She was living with the ghost of her elegant mother."

69 THE CRÊPE MAKER:
"For me, wearing a dress is a bit like being dressed up like a penguin. I always feel like I'm wearing a costume."

70 "What's the very first word that comes to mind when you think of a dress?" "*Safe.*"

71 THE LAWYER: "As a child, I dreamed of wearing a dress. Dad didn't want me to; Mom didn't mind. My parents found a compromise: they let me wear a kilt when we were in Scotland, which happened once a year. I made do with that."

73 JEAN RENOIR TO JACQUES BECKER: "What surprised me most on the Armistice of 1918 was that we saw women's legs. That was a shock. Because of the shortage of fabrics, they'd shortened dresses, and suddenly all these legs appeared."

75 THE PLAYWRIGHT: "His fiancée was one of the most elegant women in Paris—but he was said to be homosexual. Gossips would say, '*When she gets undressed, he puts on her dresses.*'"

76 Yves Saint Laurent in Morocco, speaking about his dog who circled madly around the dress Ines de la Fressange was wearing: "Life is funny; I put women in trousers, but Moujik only liked women in dresses."

78 A dress is a silhouette borne by a certain demeanor.

72 A dress by any other name: the *Levites' robe of fine linen*, which "was almost similar to the alb of today, except that it had no pleats & it was their only vestment," according to a 1733 abridged Bible.

74 Such a dress occupies a space just as a country is occupied. A woman is transmuted into a nation to be conquered. A man is transmuted into a soldier, a strategist, an army general.

77 THE SINGER: "I wear only dresses because I feel free in a dress. In jeans, I feel like I'm offering the whole shape of my body to the eyes of the world, whereas a whole bunch of things can be kept under a dress—like a movie star's sunglasses, it shows everything you want to hide."

79 THE ACCOMPANIST: "When you think of it, wearing flares is like having a little dress for each leg."

80 Despite its success in the fashion world, Dior's New Look, which required yards and yards of fabric just to make one dress, scandalized some people. Fashion historian Cameron Silver wrote that at the time *certain governments even made their disapproval known and spoke of the end of Western civilization.*

81 THE VINTAGE-CLOTHING SPECIALIST: "There are 'dress' women— women for whom dressing means putting on a dress."

82 THE FAMOUS PHOTO:
On Rue Lepic in Montmartre, Paris, two furious shopkeepers tear at the Dior dress worn by a model being photographed in front of their store. The young girl, soaked in water, being tugged from side to side, oddly manages to muster a smile.

83 THE FILMMAKER:
"I find nothing more arousing than a butt in jeans. I love girls in trousers, because when they bend down something so entirely feminine appears: their little panties, the antithesis of the jeans. It's the Greek *aletheia*—truth through disclosure. In other words, a dress is superfluous; it's a pleonasm with the underpants. It makes femininity tautological."

84 THE FRANCO-ITALIAN SUPERMODEL:
"The men who are best at dressing women don't look as if they want to undress them."

86 THE POETESS:
"I think a man who desires a woman undresses her immediately. His gaze melts the material. He doesn't see the dress covering her."

85 Although every dress dresses, it's not always *dressed up*. That's a curious expression—as if it were possible to dress an item of dress, as if a dress could, on occasion, wear a special dress itself.

87 Dresses worn just once—to *please*.

88 THE GUITARIST:
"I'm always buying dresses for my girlfriend. When my imagination fails me, I get the salesgirl or a customer to try it on. I don't start flirting with them, though, because I'm concentrating on my idea."

90 THE MUSE:
"At around the age of ten, thanks to the film-club TV show *La Dernière Séance* [The Last Picture Show], I fell in love with the *glamorous* dresses of the golden age of Hollywood: the ones worn by Greta Garbo in *Grand Hotel*, Ava Gardner in *Pandora and the Flying Dutchman*, Katharine Hepburn in *High Society*, Audrey Hepburn in *Sabrina*. I still haven't gotten over them."

89 A complicated dress. A simple dress.

91 A dress by any other name: the *crinoline* and the *farthingale* (from the Spanish *vertugado*)—tickets to a world of fantasy.

93 THE TRANSLATOR:
"It's a fact that a dress on screen doesn't produce the same effect as in real life. Chanel used to say that her dresses didn't work in the movies because she wasn't a costume designer."

92 THE PLAYWRIGHT:
"In the inter-war period, French fashion was sublime, but in the movies actresses were *frumpy*. With the exception of Jacqueline Delubac, they all seemed so ordinary. Some of the dresses poor Gaby Morlay had to wear! On the other hand, when you look at the American dresses, they all had style."

11

94 THE DIRECTOR OF PHOTOGRAPHY:
"There's the mystery of being photogenic or not. If you met Isabelle Huppert in the street you wouldn't give her a passing glance, but when you film her, it's extraordinary. The strangest thing is that you have to stand in front of a camera to know. You can't predict that someone will be photogenic. I imagine it's the same thing with a dress."

95 THE VINTAGE-CLOTHING SPECIALIST:
"Frenchwomen all have a complex about being too chic. They're afraid of looking too *lady-like*, or too *girly*, or *uncool*, and in the end they don't look like anything."

96 THE SINGER:
"A woman in a dress can be seen as a tease, but in jeans you can see much more. It's paradoxical."

97 THE COLORIST:
"Frenchwomen are very chic, but very into brands."

99 THE FRANCO-ITALIAN SUPERMODEL:
"I remember a fashion show that was running late, and a Dior dress with so many tiny buttons I was terrified of losing one."

100 MISS KNIFE:
"I see a dress as a disguise just like any other."

98 As a woman explains how she juggles her dresses, we imagine her juggling, literally, with her dresses.

101 THE POET:
"Esther Williams wore some lovely dresses. She wasn't always in a swimsuit."

102 As the horseman explains that *a horse's coat can change color—which is the case with the Lipizzans, who are born dark and end up gray*—we start to dream of a *variable dress*, which changes color every time you put it on, or a *chameleon dress*, whose color tells you about the emotional state of the body inside it.

103 THE VINTAGE-CLOTHING SPECIALIST:
"Chanel made a blunder when she sold the same suit to Madame Pompidou and to Simone Veil. They found themselves at a maternity hospital opening dressed identically. Simone Veil gave the jacket to her driver so that people would see her blouse. The same thing happened to the Duchess of Windsor and Philippine de Rothschild with a wide-striped dress by Givenchy. They both laughed about it."

104 THE FRENCH WRITER:
"*Robe*? Without hesitation, I think of Robbe-Grillet, who was a lovely, bitchy, mean, intelligent man who wrote magnificently. I also think of the film *Une robe d'été*, a wonderful short by my former student François Ozon, who filmed Catherine Deneuve's dresses so hilariously in *Potiche*, his adaptation of Barillet and Grédy's play."

105 THE SINGER:
"I have either dresses that flaunt themselves to the world or self-centered dresses that keep my secrets."

106 Meditation on the Italian language, in which the masculine word *vestito* becomes a dress when it is *da sera* or *da sposa*, but a suit when it is *da uomo*, conjuring up a vision of a garment that changes according to the gender of the person wearing it.

107 THE LAWYER:
"A few years later, I wasn't interested in dresses anymore, thanks to a man who had explained to me (he hadn't said anything but I'd understood) that you could like men and be a boy."

108 *Cashmere, faille, gauze, woolen knit, wool, Liberty print, linen, moiré, chiffon, percale, poplin, satin, taffeta, plain cotton, tulle, velvet, smocked, silk brocade, crepe de chine*: the textures of a dress.

109 THE FILMMAKER:
"A beautiful dress on a beautiful woman is exactly as if Proust had marked the important passages in *Remembrance of Things Past* with a highlighter."

110 A dress by any other name: Elsa Barbage's *Dust Dress*, a Dantean assemblage made from the contents of vacuum-cleaner bags. From the hairs, moth wings, dried flower petals, shells, receipts, and candy wrappers emerges a contemporary Cinderella, who reminds us that dust, before incarnating death, was life.

111 THE FRANCO-ITALIAN SUPERMODEL:
"Galliano was capable of lying down on the floor to change the last details. Alaïa would sew adjustments to the clothes while you had them on. With Monsieur Saint Laurent or Monsieur Lagerfeld, it was the head seamstress who made the final alterations."

112 The dress belongs to the family of simple words (those you find in a picture book). It's one of the first things a child draws, along with a house, the sun, or a car.

113 THE DANDY:
"Very few couturiers know how to sew. Alaïa can sew."

114 "For whom do you mourn, Mademoiselle?" Paul Poiret, the champion of color, asked Gabrielle Chanel.
"Why, for you, Monsieur," she replied.

115 THE FASHION PHOTOGRAPHER:
"When you have a lot of money, it's too easy. You just flash your Platinum card and you get a very fine dress, which transforms you. It's too easy."

117 THE POET:
"I can remember old lady's dresses, made of a woolen knit or jersey, that emphasized their plump midriff. They are dresses too—the most touching ones."

116 There is no such thing as a noble material, only noble ideas.

118 THE FRENCH ACADEMY MEMBER:
"What does a dress make me think of? The sound of taffeta, of dresses' trains. The very elderly Corsican peasant women I knew, who were almost a hundred years old, in the 1960s."

120 Photographing a dress isn't a straightforward matter. After putting it on the dressmaker's mannequin, you have to spend five or six hours padding it, plumping it out, dressing its limbs—bringing it to life.

119 THE MUSE:
"Every dress is a new chance."

121 THE GRANDFATHER:
"To wear a dress well, you have to have good legs."

122 THE FILMMAKER:
"I absolutely do not share Truffaut's obsession with women's legs. I feel it's something that has not aged well at all—the fantasy, not the legs. The notion of *women's legs* is for me synonymous with a classical, conventional kind of cinema, the generation of men who went to *hookers*. I'm a child of the seventies, when women wore long dresses and trousers."

123 In the future: a dress in the form of a textile *vaporizer*, sprayed directly onto the body it envelops.

124 THE ACCOMPANIST:
"It should be possible for a female singer on stage not to wear a dress."

125 Wool, latex, metal, gold, glass, meat: wherever a material exists, there are hands turning it into a dress. In Mendeleyev's periodic table, you could replace the elements with dresses.

126 THE TOURIST:
"I don't feel particularly comfortable with my own body, so I wear dresses only when it's hot or I'm on vacation. For me, a dress is synonymous with vacations."

127 If the drape is the arrangement of folds in the fabric of a garment, what is the drape of a novel? Can you trip on the arrangement of folds in the fabric of its lines or paragraphs?

128 THE SINGER:
"At forty, my mother wore a young woman's dresses, dresses that swirled around and that she'd swirl around in. She was the only mom at the school like that. Everyone looked at her."

129 THE MUSE:
"Perhaps it wasn't just the dress that made me have such an effect on him, but the dress was *part of it*."

131 THE FASHION PHOTOGRAPHER:
"Trousers are always pretty much the same; a blouse is always pretty much the same; but a dress is always different."

130 THE MATHEMATICIAN:
"The heat would be directly related to the friction, and the amount of heat produced would depend on the capacity of the fabric to shed warm air. Fluctuations would tend toward 0 if external interference also tended toward 0, because the dissipation of kinetic energy is a result of friction with air molecules. Large women would create more turbulence, then, because they tend unintentionally to dress tighter. In this case, the amplitude of the dress's movements are also modulated by the wearer's own movements."

132 THE FILMMAKER:
"The problem with a dress is when it's taken off. I get the same impression as when I see a swan coming out of the water. A dress lying on the floor is ridiculous."

133 THE POET:
"It's all to do with the question, 'What is there under the dress?' The great theory of perversion, according to Freud, is that the pervert will deny that there is nothing under the dress. For him there is something—that is to say, a phallus. The transvestite's reply to that is, 'Look under the dress, there is something.'"

134 A dress is the object a color becomes.

135 THE GRANDMOTHER:
"I had pleated fern-green organza dresses that were very floaty at the hemline, made by a pleater on Rue Boissy d'Anglas. That kind of thing suits you when you're young and slim, if you want my opinion."

136 THE POETESS:
"Today, I try to convince, but when I was young I would try to seduce. I thought I was beautiful. I made sure my dresses were skintight. I could hardly walk. I loved to be cinched in at the waist, so that the garment showed all the curves of my body. It was an excuse to let people imagine my body underneath. A second skin."

137 THE GRANDFATHER:
"A successful dress is a dress that never goes out of fashion."

138 Like diamonds, shoes, or a hat, a dress is not an item of clothing. It is an accessory (the most ample accessory of them all).

139 A dress by any other name: Jesus's *seamless robe*, woven by Mary for her son, and symbol of the unity of the Church. The story tells how the robe, made when he was very young, grew with the Holy Child.

140 THE COLORIST:
"A dress also evokes the child in a dress. A woman in a dress always feels a bit like a little girl."

141 Some dresses are unwearable: they work only on paper or, prior to the sketch, only as a concept.

142 It's about one in the morning on the corner of Lexington Avenue and 52nd Street. Torrid air is blowing out of a New York subway grating. The crew on the shoot of *The Seven Year Itch* stands ready. Five thousand onlookers are watching out for the arrival of the most famous blonde in Hollywood. Little do they know that the most famous photograph in the world is about to be taken.

143 THE MUSE:
"Sometimes, the price of a beautiful dress is more than I can afford. It's terribly frustrating. The local seamstresses, who used to copy haute couture designs so well and at an affordable price, have all gone. In the evening, I think about that inaccessible dress again, and create another, even more beautiful one in my mind, as if to get my revenge."

144 THE VINTAGE-CLOTHING SPECIALIST:
"In the 1950s, the price of an haute couture dress was equivalent to today's luxury ready-to-wear. It was still within the reach of a certain section of the middle class. Today, haute couture is the preserve of the super rich."

145 THE POETESS:
"Before I got married, I used to ask a seamstress to copy famous designs for me. She would replicate Jayne Mansfield's red dresses, or the one Marilyn Monroe wore by the Niagara Falls. I loved dresses that were slit right up to the butt at the back, or slit open on the thighs; I always wanted my dresses to have a slit somewhere."

146 THE VINTAGE-CLOTHING SPECIALIST:
"In any case, in the last five or six years, women haven't dared wear lavishly embroidered dresses or long evening gowns. Socialist president François Mitterrand killed fashion when he was elected in 1981, because, overnight, husbands were saying to their wives, 'Dress more discreetly, stop wearing furs, or diamonds, or anything.' It was a real break with the past."

147 THE DANDY:
"Up until the advent of ready-to-wear, many women would make their own dresses using patterns from magazines. There was this idea that you could choose a design and a material, and that every dress was unique."

148 THE STUDENT:
"When I think of a dress, I think of the word *princess*. Then, New Year's Eve. It's always a chore to look for a dress *for New Year's Eve*. I go to every possible store and I never find anything I like."

149 *A three-hole dress.* Erotic by name (before imagining the image).

151 THE POETESS:
"When I was young, I couldn't conceive of wearing a dress that wasn't sexy."

150 THE VINTAGE-CLOTHING SPECIALIST:
"There's a certain sensuality in slipping on a dress. And then there's the zipping it up."

152 No dress was more political than Madame de Staël's, when she declared, "The empire dress is the only thing I like about the Empire."

154 A dress by any other name: the *Robe of Nessus*. Deianeira was victim of her own jealousy, and of the dying centaur Nessus's treacherous advice to soak a robe in his blood and give it to her husband, Hercules, to prevent him becoming enamored of another woman. But the recommendation and the robe proved fatal: as soon as Hercules donned the garment, the blood turned to poison, penetrating his skin and burning him alive.

153 In *Les Misérables*, Victor Hugo made reference to the astonishing notices that, in Victorian times, were "posted on the interior walls of public toilets in England: *Please adjust your dress before leaving.*"[3]

155 THE DANDY:
"I can think of no more wonderful thing to say about dresses than Saint Laurent's declaration that the most beautiful clothes that can dress a woman are the arms of the man she loves. When you've said that, you've said it all."

156 *Newborn dress, christening dress, first communion dress, house dress, cocktail dress, dressy dress, Sunday dress, day dress, mid-season dress, summer dress, carriage dress, mourning dress, maternity dress, sun dress, party dress:* the various moments of a dress.

157 THE BARRISTER:
"I made my first appearance in court dress on a Sunday. I was pleading the case of a woman whose immigration papers weren't in order. She called me her 'black angel.' She had huge faith in me."

158 Hypothesis: with respect to this item of clothing, there is no fantasy, no memory, no shock.

160 Matisse said of his collages that he used both the form and its *counter*—that is, the inner, or exterior, space delineated by the form. Similarly, when designing a letter form, a typographer takes into account the surrounding empty space.

One could imagine a couturier who might design dresses not only in relation to their form but also their *counter*. Except that a garment is not delimited by a frame or a page: its counter is the infinite space of the world.

162 THE FACE OF CHANEL:
"Fashion is crafts-manship. Why must everything be art? Art is by definition useless, whereas a dress, well, you have to wear it at some point, otherwise it isn't a dress anymore."

163 *Swishing, rustling, crumpling, brushing, jingling, swooshing, sliding*: the sounds of a dress.

164 THE FILM HISTORIAN:
"I believe this particular costume to be more suitable for staging a woman's body—and for keeping it at a distance."

159 THE MUSE:
"A real dress has to achieve a combination of the earth and the air."

161 THE FILM HISTORIAN:
"Dresses? They're something I can't abide. Something that conceals the body, that opposes the masculine. I don't mind cardinals' robes, vestments, and other such swishing ecclesiastic garb. Or dressing gowns, when they're worn by Noël Coward or Oscar Wilde."

165 A dress by any other name: the *toga praetexta*, the long white robe with a purple border worn by the male children of patrician families in ancient Rome. It was also the inspiration for François Mauriac's second novel, *La Robe Prétexte* (*The Stuff of Youth*), published in 1914, which looks at a young intellectual leaving his childhood behind. Casting off this robe marks the beginning of adulthood.

166 THE PLAYWRIGHT:
"Dresses shaped my childhood and teenage years. I was an avid reader of my mother's fashion magazines: *Vogue* (my favorite), *Femina*, and *Le Jardin des modes*. I wasn't particularly interested in the suits and afternoon dresses. I went straight to the evening gowns. At school, during math lessons, I used to sketch the dresses worn by movie stars in my notebook, while the boy sitting next to me concentrated on his drawings of aerodynamic cars. Once we were caught by the teacher."

167 In the 1996 Dutch film *The Dress*, a dress travels from person to person, bringing misfortune to the woman unlucky enough to lay her hands on it. It is like a form of experiment, the conclusion being that a dress can play the leading role in a screenplay.

168 "Did your mother wear dresses?"
"I don't talk about my private life."

169 THE PLAYWRIGHT:
"I distinctly remember a costume that Annabella wore in Marcel L'Herbier's film *Veille d'armes* [The Eve of the Battle]. It was a white satin dress with a plunging neckline made up of large calla lilies, like a necklace. I still look at it from time to time on the Internet and find it very beautiful. Another dress by Balenciaga made its mark on theater history for me. It was almost a crinoline, with black taffeta flounces, worn by the actress Alice Cocéa in Armand Salacrou's play *Histoire de rire* [Story of Laughter]. She emerged onto the stage through a trap door and, as she climbed the steps, her skirt opened up into a corolla. It was spectacular. The audience applauded that entrance."

170 THE VINTAGE-CLOTHING SPECIALIST:
"I don't lend French actresses clothes anymore, because they don't wash themselves. Ms. X, Ms. Y, Ms. Z, and all the others—no, thanks. They aren't clean. They split the linings, sweat in the clothes, and then they want to borrow Saint Laurent's 1967 haute couture tuxedo with the transparent chiffon blouse. Ms. Z brought me back—in a plastic shopping bag—a Courrèges evening gown that was *so dirty* I was forced to throw it away."

171 *Loose, puffy, slinky, shift, pinafore, mini, straight, flowing, floor-length,* *high-necked, pleated, frilly, high-waisted, low-waisted, flounced*: the shapes of a dress.

172 In some old book:
Every intelligent woman will succeed in appearing new all the time, so as to continuously trump a man's polygamous instinct.

173 THE AMAZONIAN:
"I often think of dresses as I'm falling asleep. I dream of dresses that combine the elegance of Marlene Dietrich, the rigidity of Dior's New Look, the fractal analysis of tree growth, and the supple, organic forms of the tropical rainforest."

176 To be on good or on bad terms with one's dress.

174 Every spring (as in 1918), billions of men delight in seeing *girls' legs* suddenly on show.

175 THE COLLECTOR:
"A dress is freedom: it's light, practical, can be slipped into a bag, and is simple to put on: you just zip it up and off you go."

177 THE KLEZMER FIDDLER:
"In the basement of our house, there was a mysterious cardboard box that we weren't allowed to touch, because it contained my mother's wedding dress. She'd never worn it again. One evening, we disobeyed. We opened the box, expecting to find a Sleeping Beauty dress; but the thing was completely coming apart, moth-eaten and dusty. It was as if she'd packed up the dream of her youth in a box, and, in opening the box, we'd made the dream disintegrate."

178 MISS KNIFE:
"My first contact with dresses was with those I sewed for my many dolls."

179 THE VINTAGE-CLOTHING SPECIALIST:
"Generally, a woman who bitches about Catherine Deneuve is getting on a bit, is blonde, and has squeezed herself into a dress that's too small for her."

180 A dress by any other name: the *toga virilis*, which replaced the *toga praetexta* when Roman boys came of age.

182 *Shirt dress, shirtwaist dress, sheath dress, coat dress, dress suit, sweater dress, pinafore dress, riding dress, tulip dress, cocoon dress, tube dress, tunic dress*: the compounds of a dress.

181 THE FASHION HISTORIAN:
"For me, a girl in a black suit is much sexier than a girl in a long dress. I think that what some see as a symbol of women's freedom is really a form of prison. I'm not sure that a thong, or a figure-hugging t-shirt, or tight trousers, or a dress with a train constitute complete and utter liberty."

185 *Asymmetrical collar, wing collar, shawl collar, shirt collar, Peter Pan collar, mandarin collar, sailor collar, butterfly collar, stand-up collar, Roman collar, boat neck, cowl neck, zip neck, turtleneck, scoop neck, V-neck, bow-tie neck, polo neck*: the necklines of a dress.

183 THE FACE OF CHANEL:
"A woman in a dress, in the countryside, in summertime, with her hair loose—that is the picture of freedom for me."

186 THE MOTHER:
"A dress conjures up lightness for me, a skipping feeling. I associate it with games of hopscotch in the school playground, or the one my sister and I drew on the wooden floor of our bedroom, after rolling up the rug."

184 Was Dorothy Parker ever in love, to ask herself, "Where's the man that could ease a heart like a satin gown?"

188 THE PERFORMER:
"I loved the idea, in fashion history, of being the couturier who'd made only one dress in his life."

189 In any new dress, imitation and differentiation go hand in hand.

187 Such a usage is rare—because a dress is by nature an item that requires *qualification*—but in old French texts you come across the word *robette*, which means a "little dress."

190 THE COLLECTOR:
"A dress is also about sexuality (it can be worn without underwear), and it is a garment full of promise (think of a lover exclaiming, 'Put on a dress!')."

191 Despite its function, categories, and elements, and like *space, time, movement, number,* and *equality,* a dress emerges as a primitive word in the Pascalian sense of the term—that is to say, a word that cannot be defined otherwise than in terms of the natural idea one has of it.

192 THE COLORIST:
"There are times when you'd want to keep your dress on with a man, make love in your dress, I mean without lifting up the dress."

194 In *You and Me (Toi et Moi)* appear these charmingly antiquated lines by the poet Paul Géraldy: *Be sensible / and rest more, / write more, / think of Me. / . . . / Then that new dress / that suited you so well— / why should you want to wear it? / Jealous? Oh no; / but you can never tell / that you won't tear it. / Must you be quite so desperately smart? / Why need you fuss? / Keep all your loveliness for me, my heart. / Keep it for . . . Us.*

198 THE FASHION PHOTOGRAPHER:
"Whatever the dress she's wearing, I am always interested in an interesting woman who has fascinating things to say."

199 THE ARGENTINIAN PAINTER:
"She had stained her most expensive dress, it was a disaster. Instead of trying to clean it, she got up and said to me, 'Paint it.'"

201 THE PUNCTUATION PRO:
"What's funny are all these girls who talk about dresses, who love dresses, but who never wear them."

193 Women, *superwomen*, women *dressed up* as women.

195 THE FASHION HISTORIAN:
"It's obvious that male couturiers, who are pretty much all homosexuals, have a fantasized idea of femininity. They sometimes have a way of burying the woman, to the extent of making a travesty or caricature of her."

197 In *La Femme et la Robe* [The Woman and the Dress] one can find these enchantingly awkward lines by Élisabeth de Gramont, a friend of Proust: *Though woman and dress seem inseparable / Which of the two do you see as preferable, / And should you choose against all reason / Woman without dress or dress without woman?*

200 Darkness over the body in the form of a dress; half revelation, half mystery.

202 The third most beautiful dress: *Terre de la Montée des Anges* [Land of the Angels' Rise]—a unique work by Jan Fabre made entirely of jewel beetles, and a masterly construction in hues of bronze, green, and golden brown seemingly designed to suck the life from the eyes examining it. ·

196 THE FRANCO-ITALIAN SUPERMODEL:
"My mother wore a phosphorescent cream and gold dress, which she put outside all day in the sunshine, so that it would light up in the dark in the evening. It was very 1970s."

The second most beautiful dress: Alexander McQueen's Kate Moss hologram—revolving in suspension, as if embroidered with clouds.

The most beautiful dress: the one hidden behind the word *dress*—the one that will only ever remain there.

1. *Cyrano de Bergerac*, trans. Humbert Wolfe (London: Hutchinson, 1937).
2. Charles Baudelaire, "The Painter of Modern Life," *Baudelaire: Selected Writings on Art and Literature*, ed. Robert Baldick and Betty Radice, trans. P. E. Charvet (London: Penguin Books, 1972).
3. Victor Hugo, *Les Misérables: A New Unabridged Translation*, Signet Classics reissue, trans. Lee Fahnestock, Norman MacAfee, and Charles Edwin Wilbur (New York: Penguin, 1987).

1915	23
1920	32
1930	52
1940	72
1950	92
1960	112
1970	132
1980	152
1990	172
2000	192
2010	212
2015	223

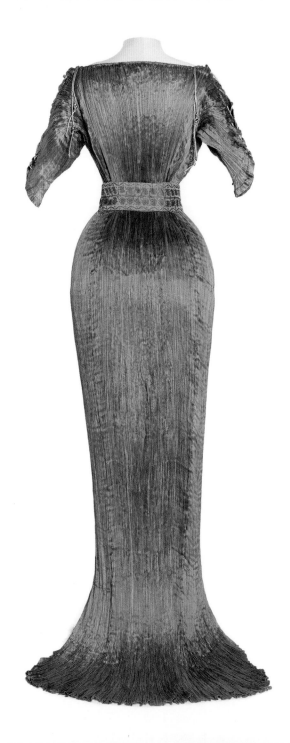

The fabrics that are new this year are, to our great surprise, quite as rich in quality, as delicate and varied in hue, and as perfectly supple as those in use before the war ruined our northern mills, and paralyzed the Lyon dyeing factories owing to the absence of the workers.

Coline, "Élégances parisiennes. Tissus nouveaux," **La Femme de France**, September 12, 1915

MARIANO FORTUNY

Delphos evening gown,
c. 1910–15 (haute couture).
Pleated silk satin,
Murano glass beads,
white silk cord, silk.

1915

The white smocks that we had long abandoned are back in fashion, to offset the severity of our semi-mourning clothes. The revival of this fashion has come in sad circumstances, but children and elderly people are not fond of black, and, often for their sakes, and whatever the cost to us, we have decided to don white smocks that look more cheerful than dresses all in black.

La Mode Illustrée, 1916

1916

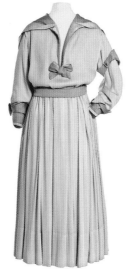

JEANNE LANVIN

Nurse's uniform, 1916, Summer collection (haute couture). Loose top in ivory silk serge with sailor collar, white skirt in ribbed cotton edged with a band of crochet lace.

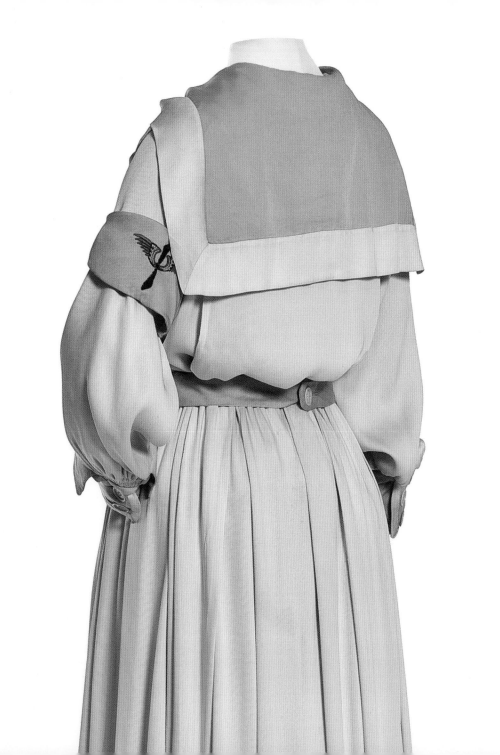

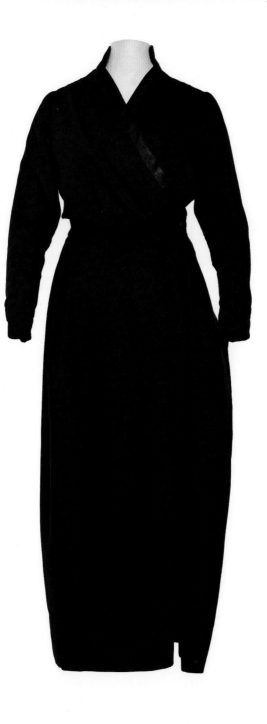

To be worn correctly, mourning dress requires not only a hat with a veil and a crepe dress, but also a specific way of grooming oneself, in which all of the details contribute to an overall impression of restraint and decency.

"La mode pendant la guerre," **Femina**, September 1917

CHARLES DRECOLL

Mourning dress, c. 1914–17 (haute couture). Wool twill trimmed with glossy black braided ribbons.

1917

What is regrettable from the point of view of fashion is the scarcity of fabrics, as hard to find as paper and which vie with the latter—albeit unsuccessfully—in the battle of rising prices.

Germaine, "Propos sur la mode," **Le Cachet de Paris**, May 1918

MADELEINE VIONNET

Dress, 1918, Summer collection (haute couture). Black crepe de chine, skirt appliquéd with black panne velvet roses, inset belt.

1918

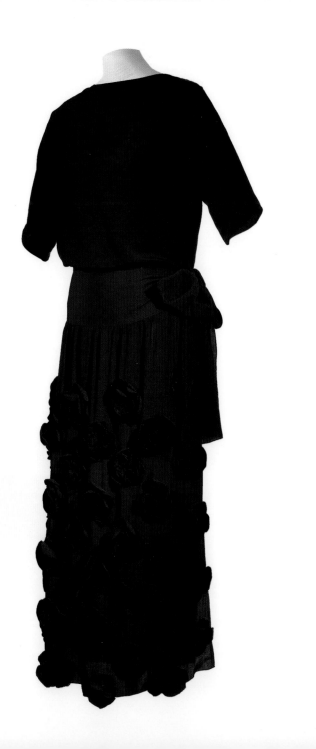

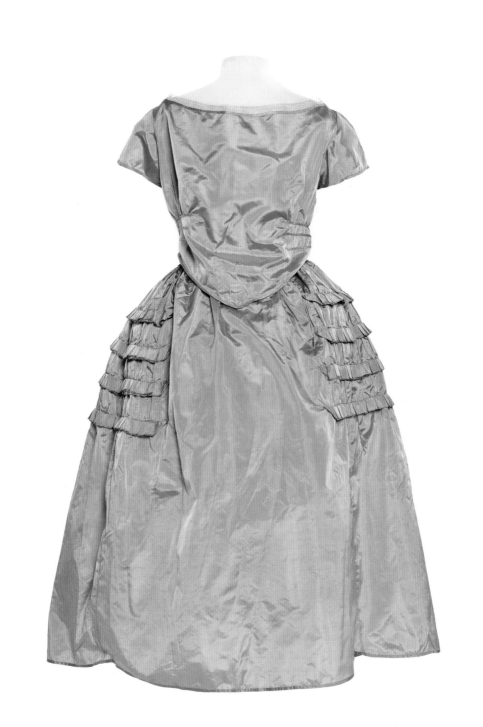

One look at Jeanne Lanvin's designs
in rue Gontaut-Biron and you're
hooked.... [Her] palette was already
famous.... Every day she adds
other new colors, some of them
a touch impressionistic, in the
bolder tones, others in amiable
eighteenth-century hues.

Le Figaro, June 18, 1918

JEANNE LANVIN

Robe de style, 1919-20,
Winter collection (haute
couture). Iridescent sky-blue
silk taffeta, cream silk tulle
collar, long full skirt gathered
at the waist and hips.

1919

The town dresses have the kind of
charming yet elegant simplicity that
every fashionable woman adores....
However, the more highly colored
and richly toned fashion becomes,
the more careful we must be and
the more exacting in our choices
to ensure that we are truly well
and tastefully dressed.

Toilettes Parisiennes, no. 245, 1920

1920

PAUL POIRET

Young girl's dress, c. 1920
(haute couture). Ivory silk
satin top with a woodblock
print by the studio Atelier
Martine, royal blue
crepe-de-chine skirt.

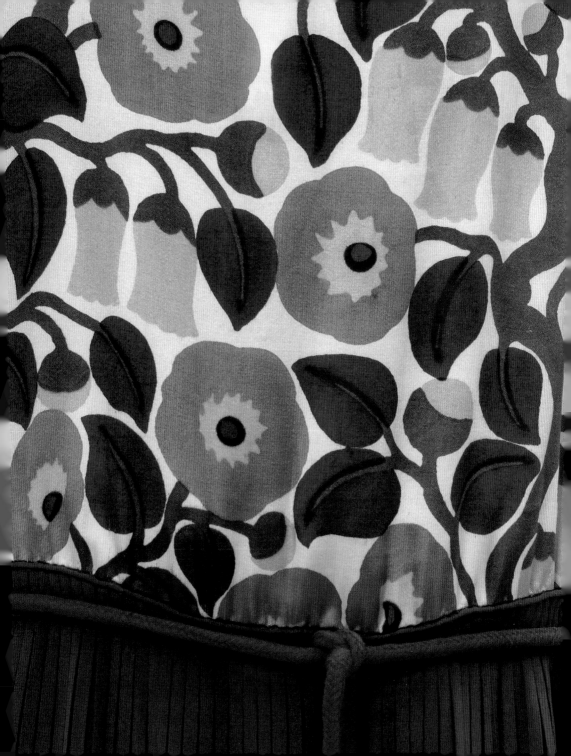

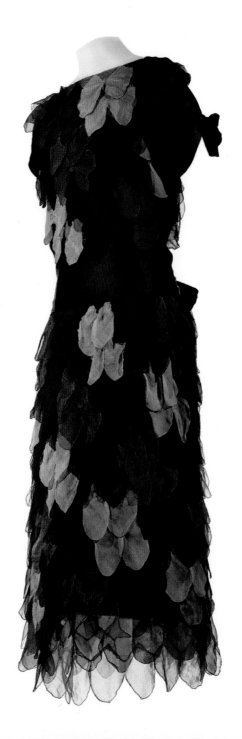

Some sixty parrots were hanging on
their perches: marvelous to behold!
Multicolored birds—pink-tailed
African grays, dark blue monals and
macaws, brown and pale yellow
amazons, red-crested white cockatoos,
all swinging to and fro. Sometimes,
my dear lady friend remembers
the macaws. She appears wearing
a brightly colored piece of lace.

Gérard Bauër, **La Gazette du Bon Ton**, January–June 1921

MADELEINE VIONNET

Essuie-plume [Penwiper]
dress, 1921, Summer
collection (haute couture).
Black, green, and purple silk
chiffon, appliquéd cut-out
petals in black, purple,
and emerald green.

1921

It is the elegant hour.
The supreme hour for walking.
I pass a lithe silhouette,
perfectly harmonious in its lines.

A.P.V., **Le Temps**, December 22, 1922

MADELEINE VIONNET

L'Orage [Storm] afternoon dress, 1922, Summer collection (haute couture). Silk toile in graduated shades, square motifs cut on the straight grain, edged with gold stitched border.

1922

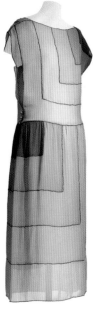

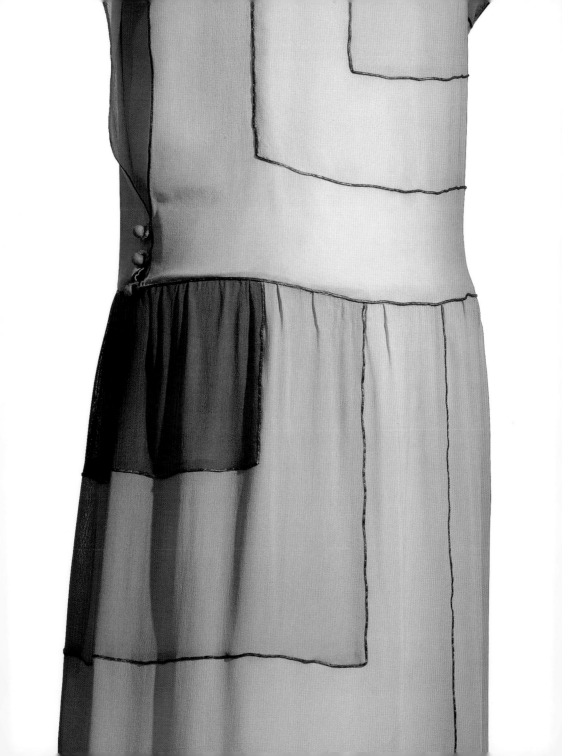

My dress was a success. For three weeks it had been the object of the most studious research and the most serious hesitations. After considering all of the colors and all of the forms it might take, Mother and I ended up quarreling, so we had to get someone to arbitrate.

"Carnet d'une jeune fille," **Femina**, June 1923

PHILIPPE ET GASTON

Evening gown attributed to Philippe Hecht and Gaston Kauffmann, c. 1921–23 (haute couture). Blue-green silk velvet handpainted by Marguerite Cornillac, velvet ribbon belt.

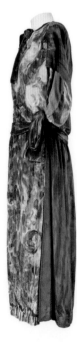

1923

Fortunately there is a remedy for those who suffer from the ailment of never being at ease, wherever they are.
It consists in giving them the feeling that they couldn't be better anywhere else. A dress has a thing or two to teach us in that respect.

Coriandre, **La Gazette du Bon Ton**, no. 3, 1924-25

1924

PAUL POIRET

Fils du Ciel [Threads/Son of Heaven] dress, 1923–24, Fall–Winter collection (haute couture). Red silk velvet with gold machine embroidery, black satin trim.

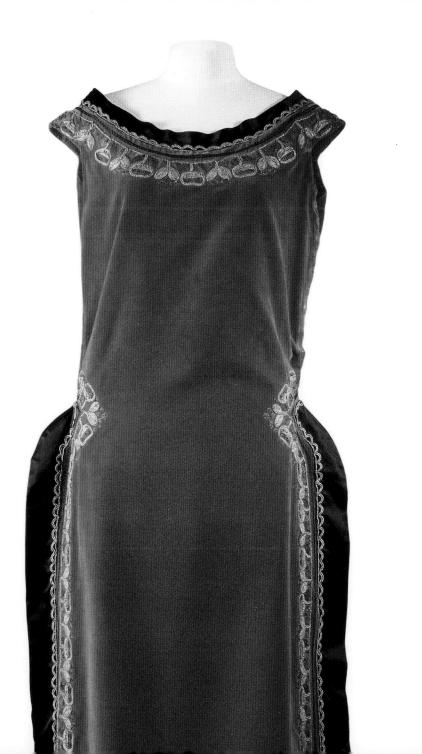

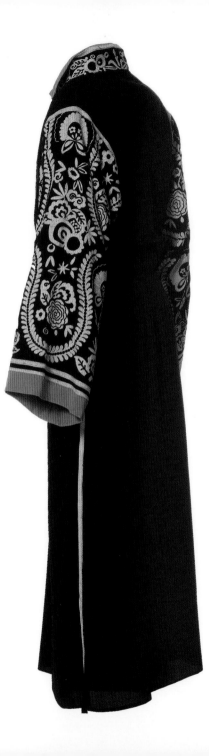

The female silhouette has become flat. A teenage girl makes a better model today than the Venus de Milo.

René Bizet, "Considérations sur la mode et les mœurs," **La Mode**, Paris: F. Rieder, 1925

NICOLE GROULT

Tunic dress attributed to Nicole Groult, c. 1925 (haute couture). Black marocain, sleeves lined with orange crepe de chine, cream silk embroidered motifs.

1925

Madeleine Vionnet, an artist enamored of the ancient ideal of beauty and the harmony of the female body.

"Portrait de Madeleine Vionnet," **Vogue**, March 1926

1926

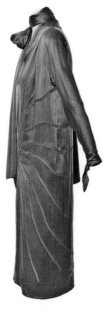

MADELEINE VIONNET

Evening gown, 1926, Summer collection (haute couture). Green silk satin crepe, thin inset bands of green chiffon.

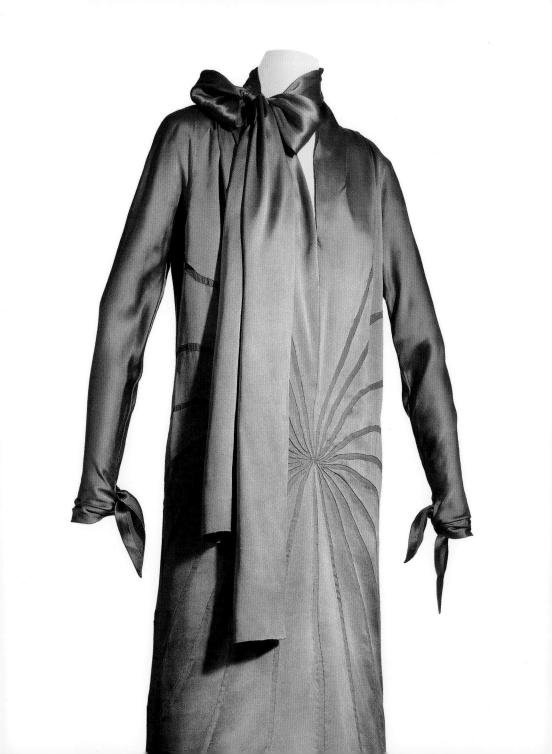

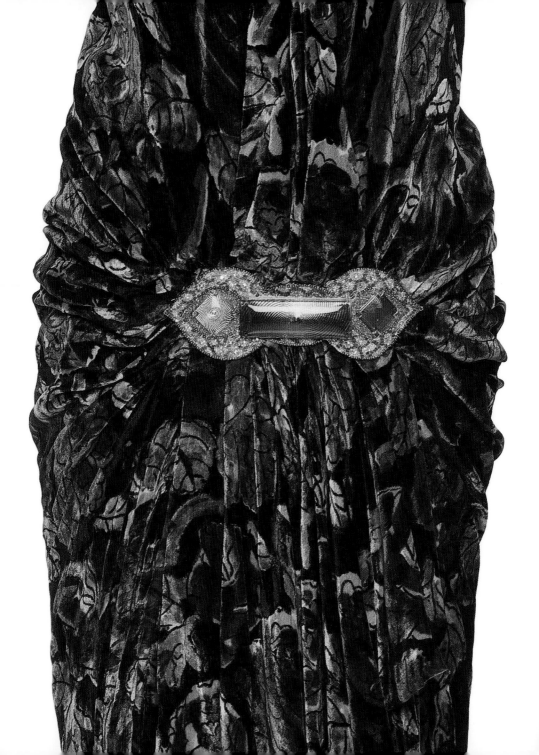

Callot stays faithful to the tradition of the woman who is "unique," endeavoring to give each dress an almost personal character. Fashion is essentially the enemy of uniformity; every artist knows it, and the artisans of couture should not forget it.

Alice Cocéa, quoted in "La Comtesse Stanislas de la Rochefoucauld nous dit ce que doit être la Mode moderne," **L'Officiel de la Mode**, April 1927

CALLOT SŒURS

Evening gown, c. 1925–27 (haute couture). Panne velvet with a rose motif print, embroidered with beads, tube beads, and rhinestones, loose draped bodice.

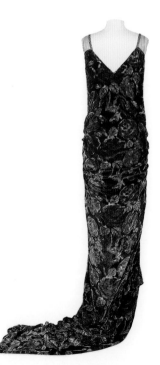

1927

The fabrics used for this kind of draping are extremely light; these dresses often feature winged sleeves, attached only at the shoulder, which give the silhouette a very elegant look.

"Les robes du soir," **Le Cachet de Paris**, January 1928

1928

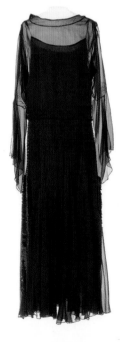

PREMET

Evening gown, c. 1928–30 (haute couture). Black chiffon over black silk crepe, skirt embroidered with beads and sequins.

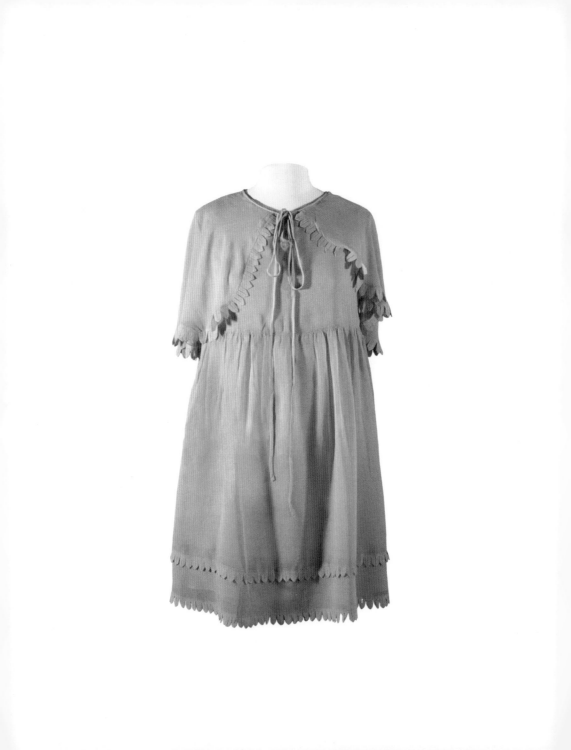

This powerful woman's wisdom
is transmitted to the child through
an imperceptible yet unmysterious
channel: the child imitates its mother.
That is how it learns to smile, to speak,
and to hold its head up.

Jacques Ganuchaud, "La mère, première éducatrice," **La Mère Éducatrice**,
July–August–September 1929

JEANNE LANVIN

Young bridesmaid dress,
1929, Summer collection
(haute couture). Old rose
crepe georgette lined with
pink silk satin.

1929

Fashion is insolent, harsh, cruel like a young generation that respects nothing from the past or the future, and the melancholy and nobility emanating from its forms, its initiatives, its carefree aura come from the fact that it will die young, and that it knows it, and that it's giving all it's got.

Jean Cocteau, "La mode et les artistes," 1930, quoted in **Cocteau et la Mode**, Paris: Éditions Passage du Marais/Cahiers Jean Cocteau, 2004

1930

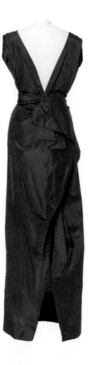

ELSA SCHIAPARELLI

Evening gown, c. 1930–35 (haute couture). Blue and purple silk taffeta.

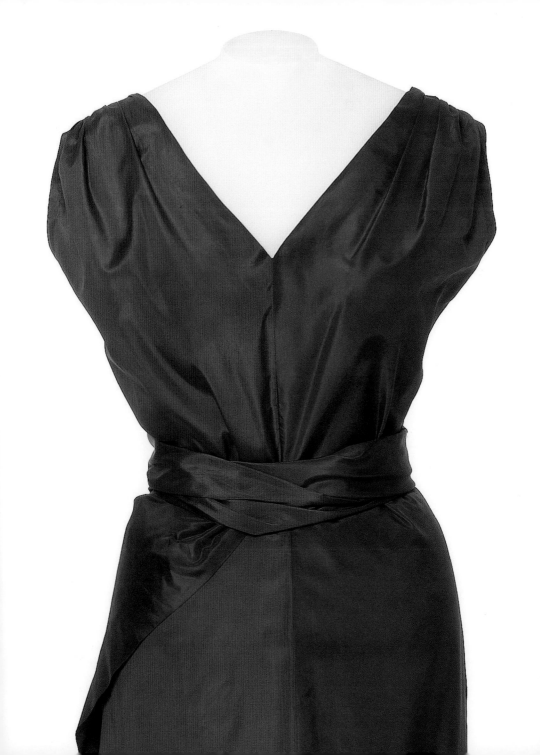

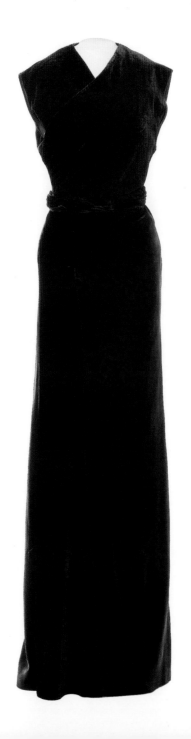

While there is no single silhouette for the evening... the various forms nevertheless have a trait in common: they are all close-fitting, hugging the curves of the bust and hips.

"Le soir," **Vogue**, March 1931

PAQUIN

Evening gown, c. 1930–35 (haute couture). Burgundy and green silk velvet, draped bodice.

1931

Allow me to say a word about what
fashion has consigned to oblivion.
It has disowned embroidery, which
it adored for so long. It has abandoned
lamé, which not so long ago it couldn't
have done without. It has consigned its
rustling taffetas to cupboards and chests
of drawers. Gone are the sequined shift
dresses.... But fashion does not feed
on memories. It lives in the present.
Let us take it as it is.

Micheline, "Ce qu'on ne porte plus," **Modes et Travaux**, December 15, 1932

1932

MAINBOCHER

Evening gown, c. 1932
(haute couture). Silver
lamé, embroidery with
small beads and sequins.

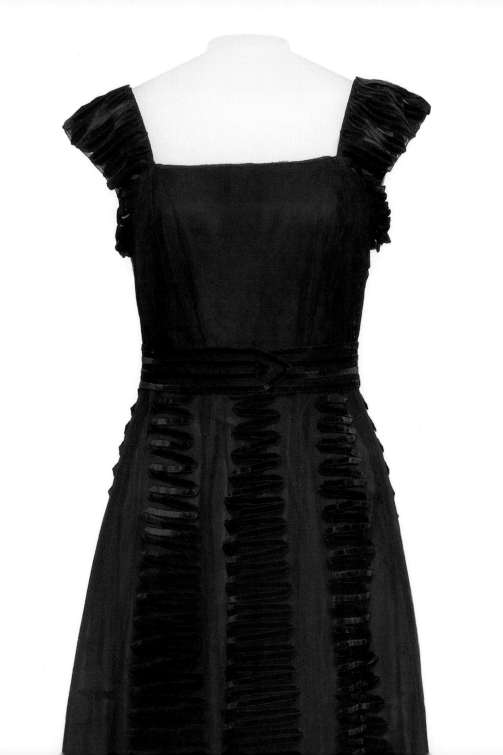

A "cut"
and not "cut-outs."

Heim (biannual journal), March 1932

HEIM
JEUNE FILLE

Evening gown, c. 1930–35
(haute couture). Blue tulle,
appliquéd velvet ribbon
over blue silk faille.

1933

But for you, naturally, the question was more serious. What would the new you be like?... So I can imagine your enthusiasm when you first set eyes on the designs assembled for you. "The Maggy Rouff dress—oh, how charming!"

Arlette, "Pour vous, Madame. Parlons chiffons," **L'Afrique du Nord Illustrée**, October 27, 1934

1934

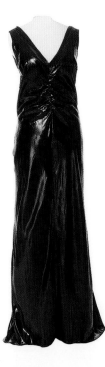

MAGGY ROUFF

Evening gown attributed to Maggy Rouff, o. 1932–35 (haute couture). Black silk satin, gathered bodice.

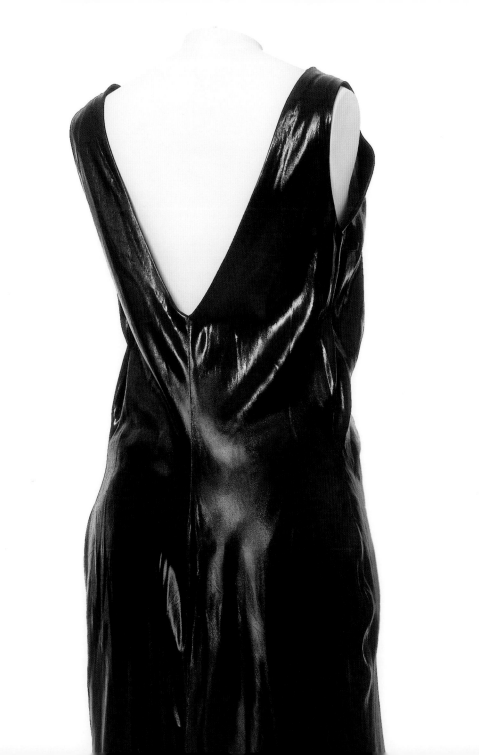

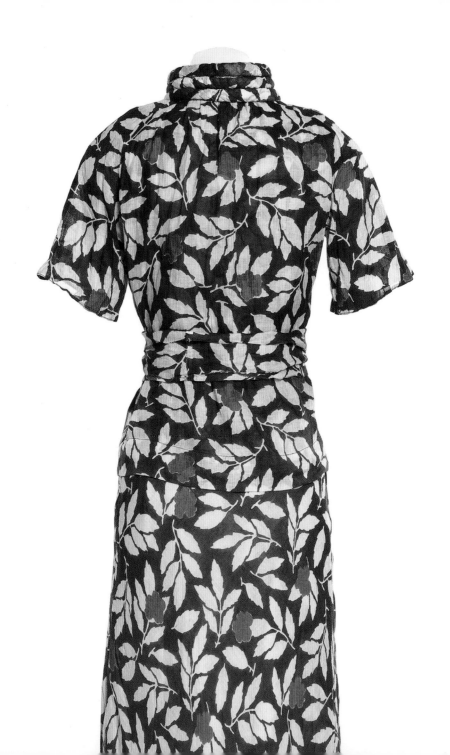

Today it takes less rose and more prose to describe a young woman. We're not talking about some literary spirit but about a well-balanced, living being, who knows how to dress and adorn herself, and how to look her best; who knows how to display the most charming traits of her character, that mixture of teenage peculiarities—or even childish graces, a certain shyness, reserve, and incompleteness—and distinct adult qualities.

Vogue, May 1935

CHANEL

Day dress and bolero,
c. 1930-35 (haute couture).
White, blue, and red printed
cotton voile, jacket with
short raglan sleeves and
high collar with three
quilted bands.

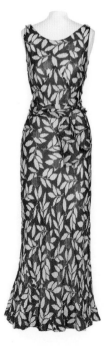

1935

The appeal of the Robert Piguet collection lies in the completely new impression that stems from every little detail. The line itself is an innovation, modifying the female silhouette while taking nothing away from its grace and litheness.

L'Officiel de la Mode, September 1936

1936

ROBERT PIGUET

Long dress, c. 1935–40 (haute couture). Dark blue wool, cotton belt with Provençal print.

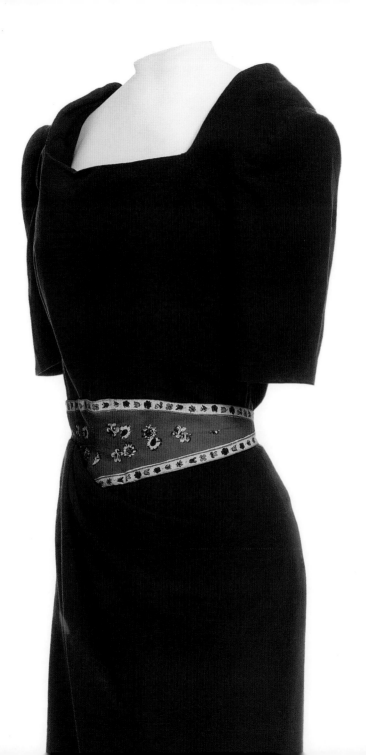

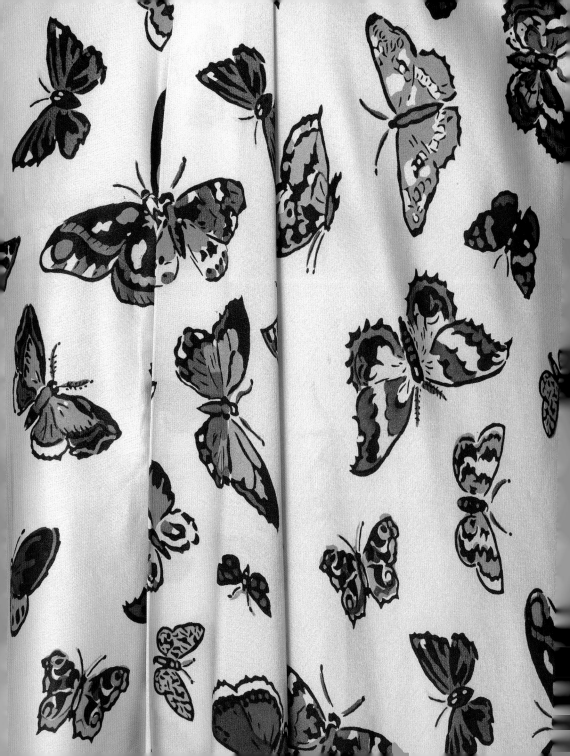

My head is full of butterflies and birds, Delphine. It's not that I'm feeling particularly poetic or bucolic today, but I have just seen a couture collection based entirely on this winged theme. Butterflies of cellophane or mica, sky blue or ocher, alighted upon… a curl of hair at the temple, the shoulder of a cape, or a dress.

Germaine Beaumont, "Lettre à Delphine," **La Femme de France**, March 15, 1937

ELSA SCHIAPARELLI

Dress and coat, 1937, Summer collection (haute couture). Long dress in printed white silk satin, coat in black horsehair netting.

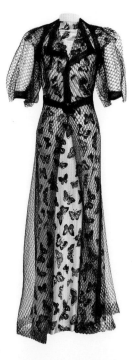

1937

The evening gowns have beautiful lines, some with remarkable chiffon pleating work, and are made with rich fabrics.

Catelan, **Le Figaro**, September 8, 1938

1938

MARCEL ROCHAS

Evening gown, c. 1938 (haute couture). Rayon crepe.

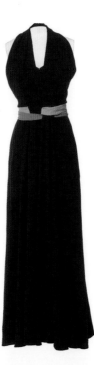

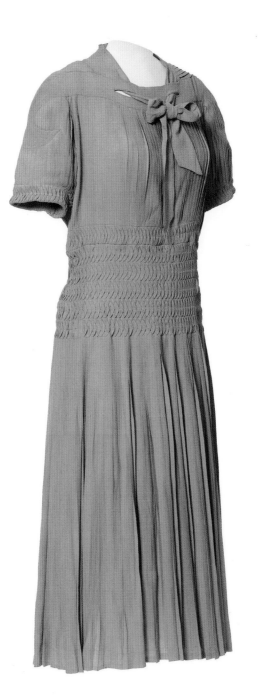

You'd be looking in vain for a defect in the cut, which is all the more remarkable as it is infinitely subtle, for Jeanne Lafaurie—while conserving youthfully simple, pretty lines—appears to be looking primarily for a very personal form of expression in her designs.

L'Officiel de la Mode, September 1939

JEANNE LAFAURIE

Day dress, 1939 (haute couture). Finely pleated and smocked matte silk crepe and silk, inset shoulder piece.

1939

Printed ensembles, polka dots, small motifs, that's the latest fashion.

"Et d'abord, sachez que...," **Marie Claire**, May 10, 1940

1940

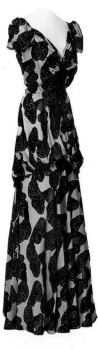

ELSA SCHIAPARELLI

Evening gown, 1939–40, Winter collection (haute couture). Patterned silk velvet over satin.

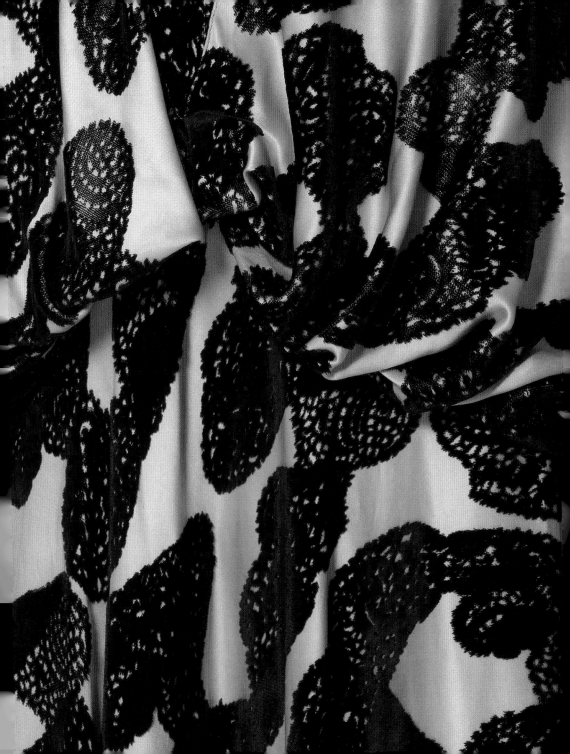

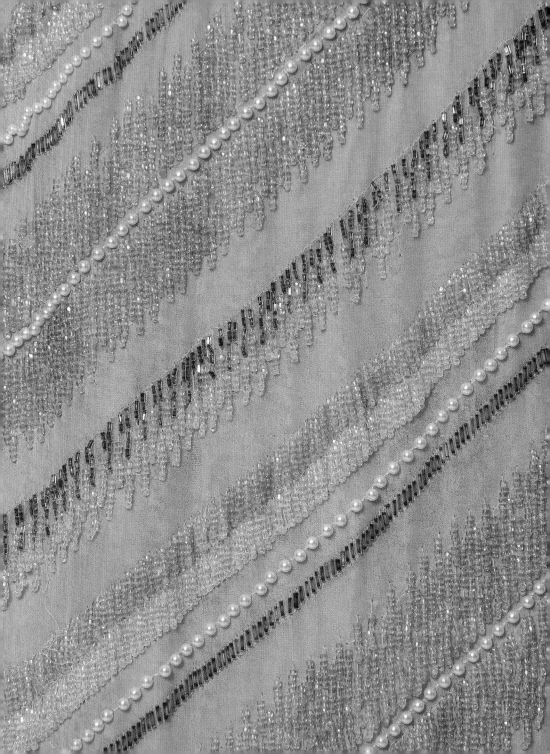

As for the dress, it looked as if downy feathers, foam from a waterfall, and rock candy had been sewn onto it, with pieces of lace like those you find at the bottom of a grandmother's chest of drawers that crumble into silvery dust when you try to unfold them.

Gaston Bonheur, "Nouvelle inédite de Gaston Bonheur," **Marie Claire**, May 10, 1940

Unlabeled

Evening gown, c. 1940–41. Pink silk chiffon, crochet embroidery with pink, pale pink, and white beads and transparent silver-lined tube beads.

1941

It was a pleasure to see Grès back on the Paris scene, where she immediately reclaimed her rightful place. We recognized the highly personal manner of this great artist, her inimitable twisted drapes, her masterly cuts and perfect adjustments.

"Collections d'hiver," **L'Officiel de la Mode**, November 1942

GRÈS

Skirt suit, c. 1942–44 (haute couture). Tartan wool twill.

1942

Dear Commissioner-General,
I have suspended the Jewish owner of the [Michel dressmaking] studio, Mr. André Michel, from his duties. However, Mr. Michel is the house's *chef de coupe* [senior pattern cutter] and he is indispensable for the smooth running of the business.... You are aware that twenty families rely on remuneration from the house for their daily bread. This moral and humanitarian point of view should suffice, I believe, for you to authorize me to keep him on as a simple employee. Respectfully awaiting your instructions, I remain yours sincerely.

Letter sent to the General Commissariat for Jewish Affairs, in Paris, March 23, 1943

Amateur Craftsmanship

Day dress, 1943. Black wool gabardine, black silk velvet bodice, collar in white cotton chiffon.

1943

Few notable changes in couture as far as the line itself is concerned. However, new details give each collection its own individual charm.

"Les collections de printemps," **L'Officiel de la Mode**, April 1944

1944

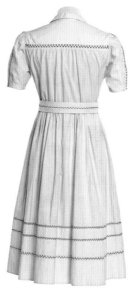

Amateur Craftsmanship

Tricolor day dress (worn by the donator on the occasion of the Liberation of Paris), 1944. White cotton toile, rickrack insets embroidered with blue and red cotton thread.

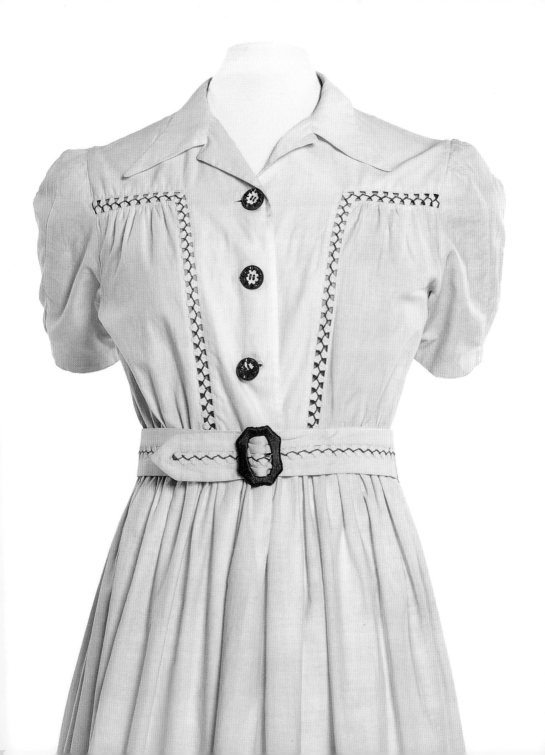

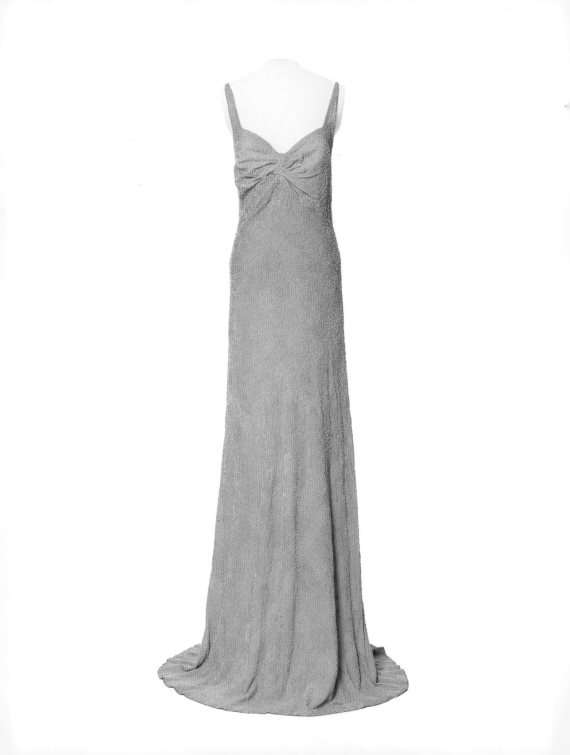

A dress was no longer to serve as a more or less decorated usefulness but to once more become a thing of beauty, to express elegance, grace, and delicacy in silk and wool, in lace, feathers, and flowers.

Gertrude Stein, Alice B. Toklas, **A New French Style**, Paris: Verly, 1946

MAINBOCHER

Evening gown, c. 1945–49
(haute couture). Light beige
silk, bead embroidery.

1945

But 1920 is in the air.
Each Lelong dress or coat
is a memory from twenty
years ago for our parents.

Alexandre Astruc, **L'Art et la Mode**, no. 2712, 1946

1946

LUCIEN LELONG

Dress, c. 1946
(haute couture).
Black wool crepe,
draped skirt.

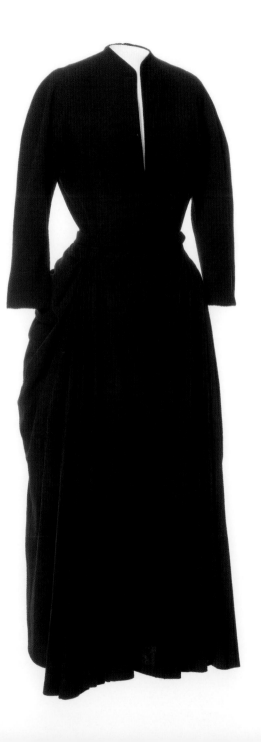

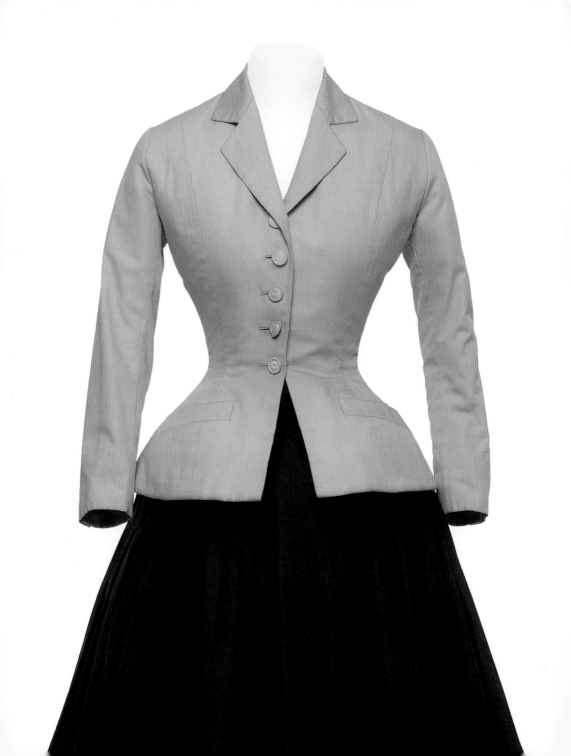

Dear Christian, your dresses have such a new look!

Declaration by Carmel Snow, editor in chief of **Harper's Bazaar**, February 12, 1947

CHRISTIAN DIOR

Bar suit (jacket and skirt), 1947, Spring–Summer collection (haute couture). Silk shantung and wool crepe.

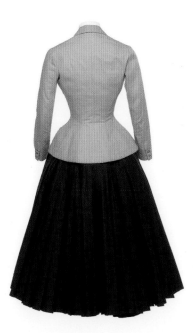

1947

There is no 1948 fashion as such, which is the sign of a great disorder and fierce individualism. Every couturier is trying to contradict his or her colleague.

Jean Cocteau, article from 1948 discovered in his archives, published as "Élégance et mode" in **Cocteau et la Mode**, Paris: Éditions Passage du Marais/ Cahiers Jean Cocteau, 2004

1948

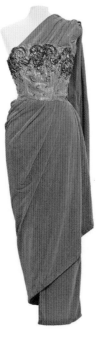

JACQUES FATH

Evening gown, 1948, Fall–Winter collection (haute couture). Bustier in gold lamé, covered with tulle embroidered with silver and gold rhinestones, tinsel foil, and sequins, floating panel in pink silk velvet.

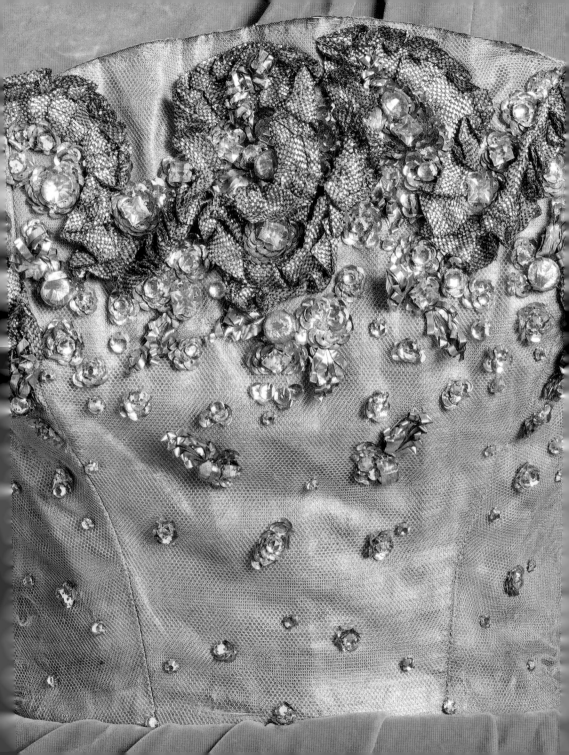

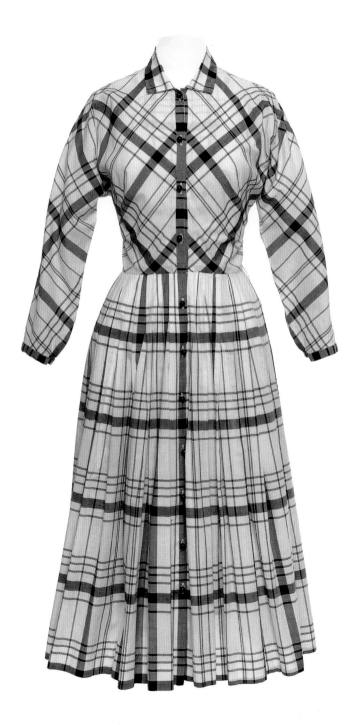

Once again a miracle has taken place in the secret laboratories of Fashion, and themes from the past have been renewed, aired, pared down, and combined with innumerable technical discoveries to produce the ephemeral style of a season.... Fine fabrics contribute to the elegance of the designs: we are still seeing a lot of tartan in coats, suits, and dresses.

"Le Printemps," **La Femme Chic**, February–March 1949

**CLAIRE
MCCARDELL**

Shirt dress, c. 1949
(ready-to-wear). Red and
black plaid over an ecru
ground in cotton toile, ball
buttons in black plastic.

1949

The drapery is still restrained, excessive fullness is banished, as are overly close-fitting lines; comfort and suppleness are de rigueur. These are dresses and ensembles in which a woman can live and move, and they must provide ease of movement and accommodate the wearer's natural postures, yet remain elegant.

"Croquis de 5 heures," **Silhouettes**, Winter 1950-51

1950

MANGUIN

Domino day dress, 1950 (haute couture). Black wool crepe, crisscross ribbed motif sewn from the underside.

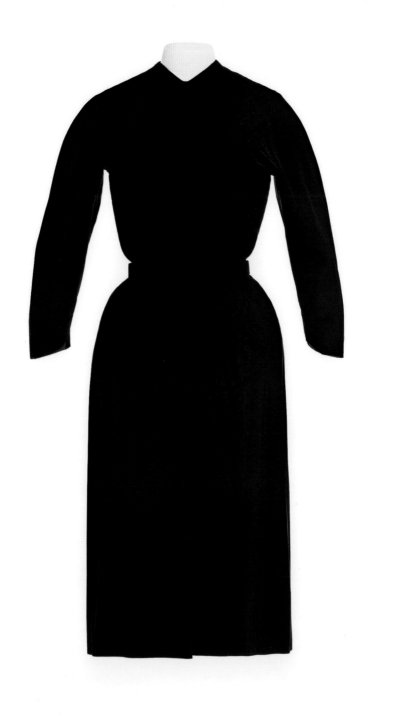

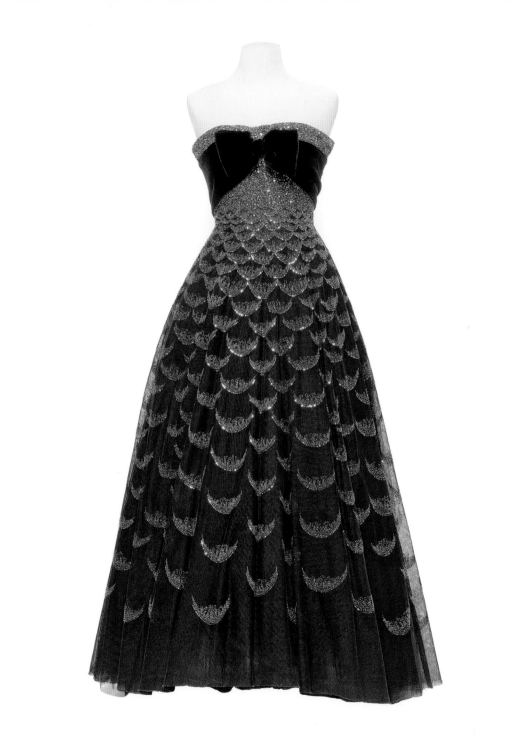

Enthusiasm or disappointment.
The toile is before me, with its lines,
volumes, shadows, and lights.
Immediately it prompts me to say,
"That's my favorite, that's the one I like,
the one I adore! At least there'll be
one good dress in the collection;
I'll base everything on that one."

Christian Dior, **Je Suis Couturier**, Paris: Éditions du Conquistador, 1951

CHRISTIAN DIOR

Mexique evening gown,
1951, Fall–Winter collection
(haute couture). Khaki,
black, and white synthetic
tulle, embroidery with gold
sequins and glass tube
beads, cream silk velvet.

1951

When the occasion called for it,
a woman could stand tall and majestic,
for static appearances. But now those
tall, beautiful women of times past have
gone, giving way to the "pretty little
women" who are popping up everywhere
today: quick, sporty, and interchangeable!

Élisabeth de Gramont, **La Femme et la Robe**, Paris/Geneva: La Palatine, 1952

HERMÈS

Hermeselle day dress,
1952 (ready-to-wear).
White cotton toile with
a brown print.

1952

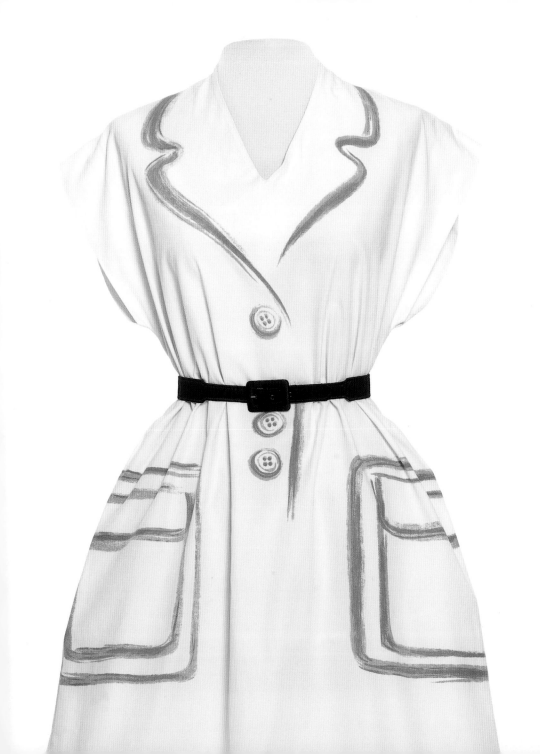

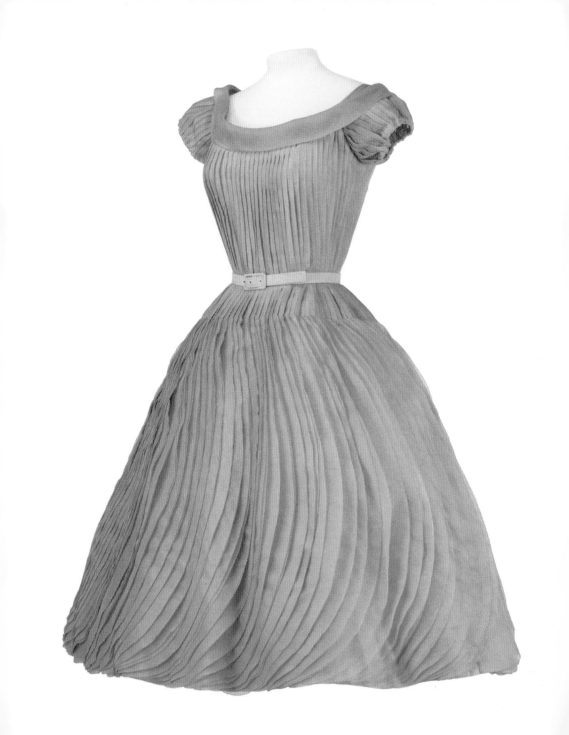

Hastily following fashion
conveniently exempts
one from having taste.

Lucien François, **Le Métier d'Être Femme**, Paris: Richard-Masse Éditeurs, 1954

JEAN DESSÈS

Cocktail dress, c. 1953
(haute couture). Pale pink
and white organza, silk
taffeta, white cotton toile
belt lined with leather.

1953

At the heart of the rose
life is flawlessly played.

Jean Sénac, "Deux chansons," **Pour une Terre Possible**,
Paris: Points Seuil, 1954

**CRISTÓBAL
BALENCIAGA**

1954

Evening gown, 1954,
Fall-Winter collection
(haute couture).
Fuchsia silk taffeta.

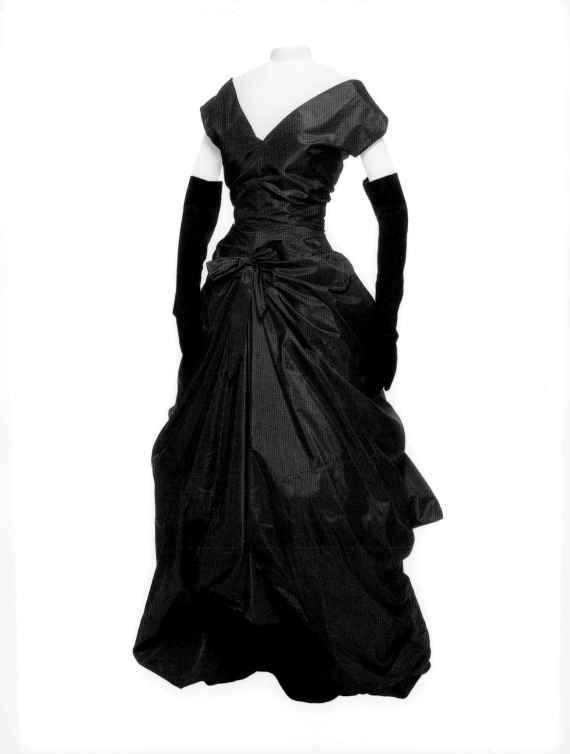

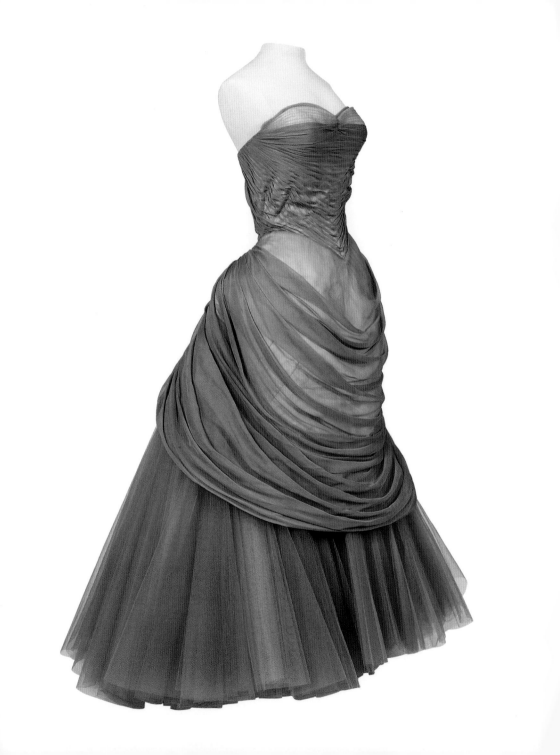

Balenciaga made no mistake when he said that James elevated his dresses to works of art. He described himself as a sculptor. One day in the summer of 1955, on a café terrace, he said to me, "Some of my designs weigh nearly twenty-five pounds, yet the women who wear them look as light as a bird or a flower."

Declaration by Pierre Barillet, playwright and friend of the couturier, 2015

CHARLES JAMES

Cygne [Swan] evening gown, 1955, Fall–Winter collection (haute couture). Pleated silk crepe and draped tulle.

1955

The Line of Heart has its own laws:

—High bust
—Belted
—Neatly cut.

"Paris lance la ligne de cœur," **Elle**, March 5, 1956

1956

**CRISTÓBAL
BALENCIAGA**

Day dress, 1956, Fall–Winter
collection (haute couture,
under the label Eisa). Black
double-woven silk cloqué.

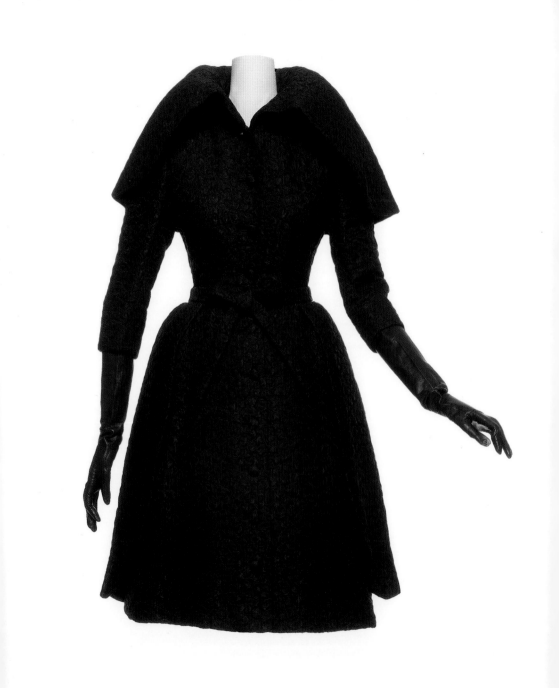

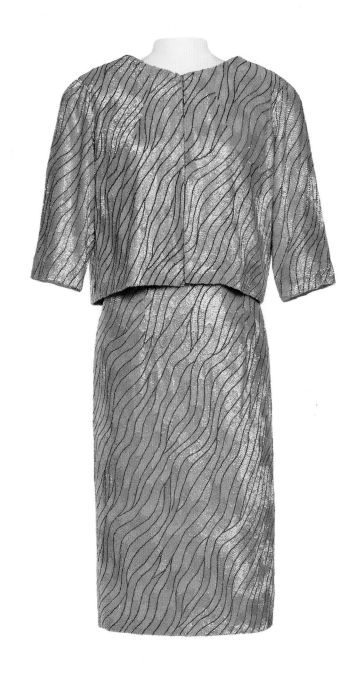

There are evening-gown years: 1957 was one of them. Royal visits and receptions caused a marvelous array of gowns to blossom in a single spring.... What is also singular about evening fashion this year is that, whereas it is usually static, it appears to be seeking new lines.... Have *"petits soirs"* [small evening occasions] become a thing of the past?

E. de Semont, "Grands soirs chez les grands couturiers," **Le Monde**, June 6, 1957

GUY LAROCHE

Dress and bolero, 1957
(haute couture). Beige silk
satin crepe, embroidery
with white and pink tube
beads and silver-lined
transparent beads.

1957

Our Dressmakers are the best in
the world and their creations
inimitable. Their tact has no equal.
It is still necessary to make it known.
Is not Renommée traditionally
represented with a trumpet at the lips?

Andrée Castanié, "On a Closed Door," **L'Officiel de la Mode**, September 1958

CHANEL

Cocktail dress, 1958 (haute
couture). Machine-made
pink lace over pink marocain,
black silk satin bias binding.

1958

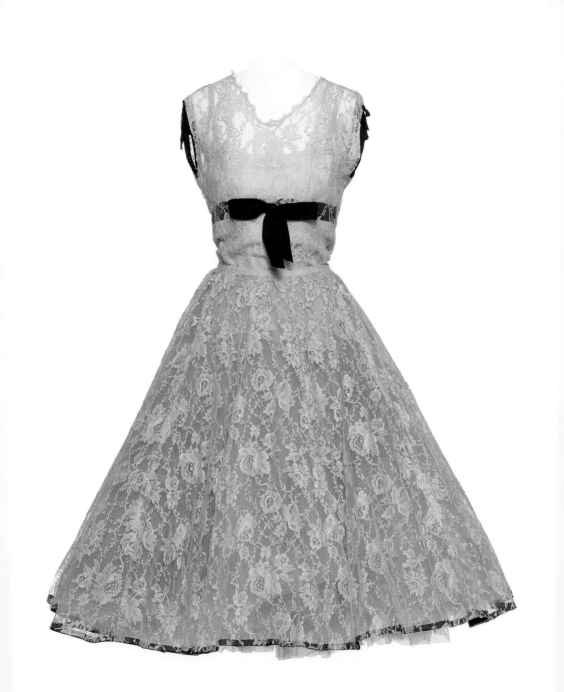

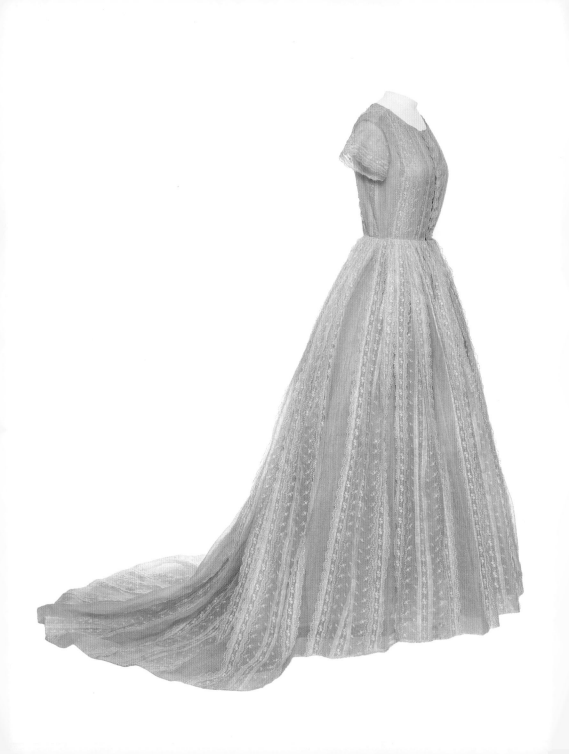

Watch out: here is a new and imaginative manner of envisioning elegance. I pity and envy the artisans who have to give substance to these dreams with a firm, precise, and inspired hand. I have little sympathy for certain gossips and society ladies who will never understand that a poet has made a devastating entrance into the small and timorous world of Paris fashion.

Lucien François, **Combat**, August 17, 1958

CHRISTIAN DIOR
by Yves Mathieu Saint Laurent

Accord Parfait [Perfect Harmony] wedding dress, 1959 (haute couture). White organdy, plumetis and ladder-stitch embroidery.

1959

Every year, there is *the* find, which, through telepathy, is to be found everywhere. In 1960, the spotlight is on shiny black, from beauty to the beast.

"Présent, piquant, grisant : le noir luisant," **Elle**, March 4, 1960

PIERRE BALMAIN

Dress, 1960 (haute couture).
Black silk gazar, inset belt.

1960

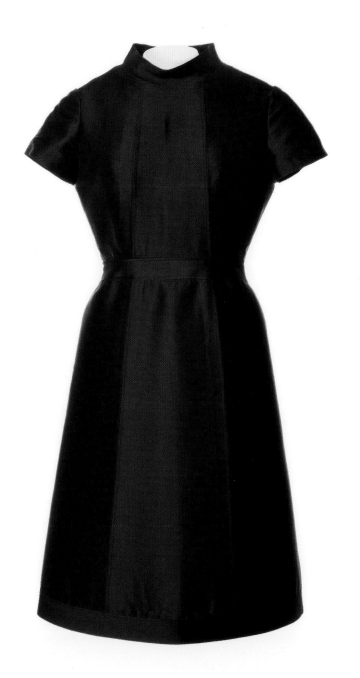

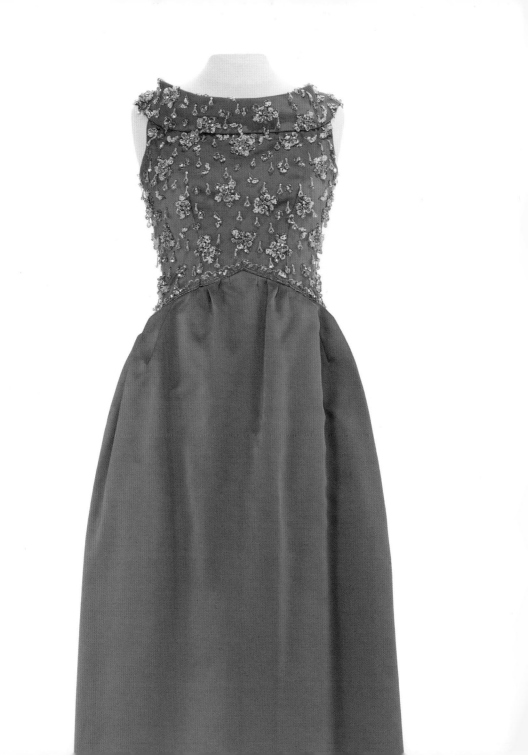

What is more surprising, in the capricious world of fashion, is that, while it obeys the dictates of the day, this kind of garment retains its legitimacy when the hour has passed. It never takes on the unworthy and touching ridicule of photographs yellowed with time.

Lucien François, **Comment un Nom Devient une Griffe**, Paris: Gallimard, 1961

JACQUES HEIM

Long evening gown,
c. 1961–62. Turquoise
duchesse satin, embroidery
with appliquéd blue and
white glass beads.

1961

Balenciaga (1962 marked the twenty-fifth anniversary of his influence on fashion) gives us a lesson in sophistication and originality.... Perceptible in places is his brand of informed boldness, which always knows just how far it can go too far.

Editorial, **Le Jardin des Modes**, November 1962

BALENCIAGA

Evening gown and cape, 1961–62, Fall–Winter collection (haute couture). Lace over purple silk satin, purple silk satin bows.

1962

"When you're designing a collection, do you think of your private clients, the professional buyers, the press, or all three?"
"I think of all three, but first I think of a woman."

Yves Saint Laurent interviewed by **Women's Wear Daily**, April 3, 1963

YVES
SAINT LAURENT

Evening gown, c. 1960–66 (haute couture). Matching appliqué and rhinestone embroidery.

1963

A recital of new ideas, free elegance, and cheerful colors, the collection of Gérard Pipart [Ricci's couture designer] is a picturesque and effective evocation of the fashions of the 1930s.

L'Officiel de la Couture et du Spectacle, March 1964

NINA RICCI
by Gérard Pipart

Evening gown, 1964, Spring–Summer collection (haute couture). Green silk gazar embroidered with flowers in various colors.

1964

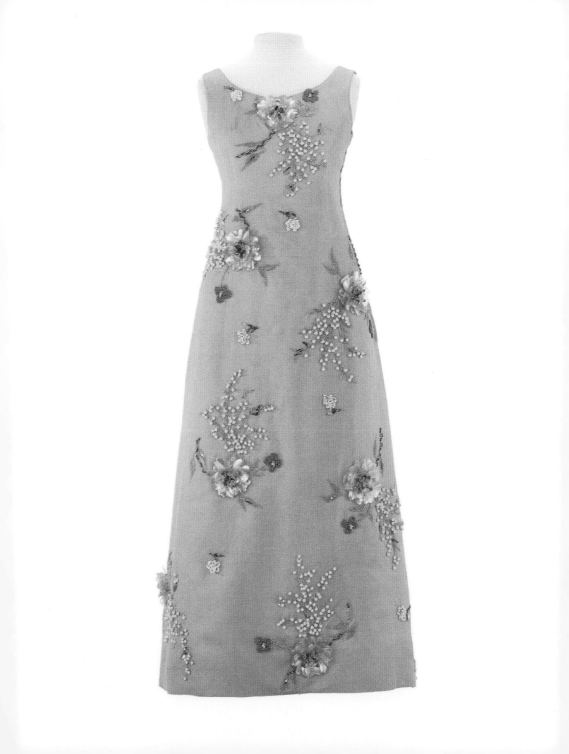

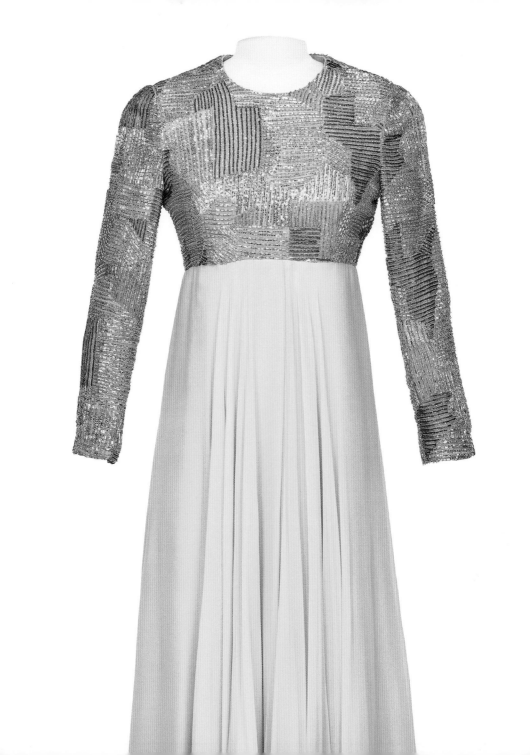

Women couldn't care less. To them
the important thing about Sarmi is that
he turns out some of the world's most
elegant evening dresses. "Every woman
with $600 to spend," says one New York
buyer, "wants to own a Sarmi."

"Fashion: Bugles, Bangles & All Woman," **Time**, June 25, 1965

**FERDINANDO
SARMI**

Evening gown, c. 1965
(haute couture).
Embroidery with beads,
tube beads, and metallic
thread, skirt in yellow
silk chiffon.

1965

A permanent trait in my designs is a sobriety that can be a little severe, combined with supple, flowing lines and a modernism softened by a certain grace.

Pierre Cardin quoted by Hélène de Turckheim, "Une symphonie en blanc pour un festival d'élégance," **Le Figaro**, November 10, 1966

1966

PIERRE CARDIN

Dress and cape, 1966, Fall-Winter collection (haute couture). Patterned pale orange laméd silk, silk taffeta, orange-dyed fur hem, cape in wool twill.

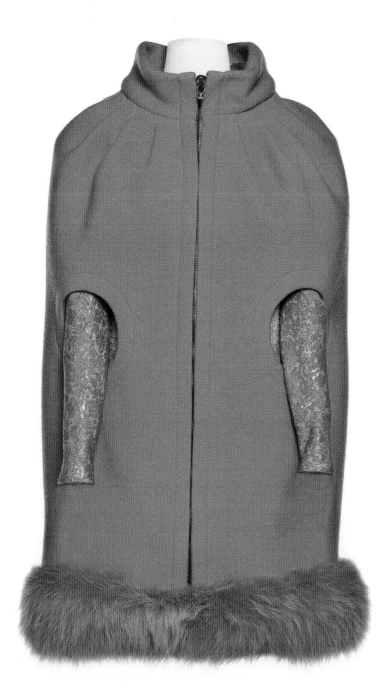

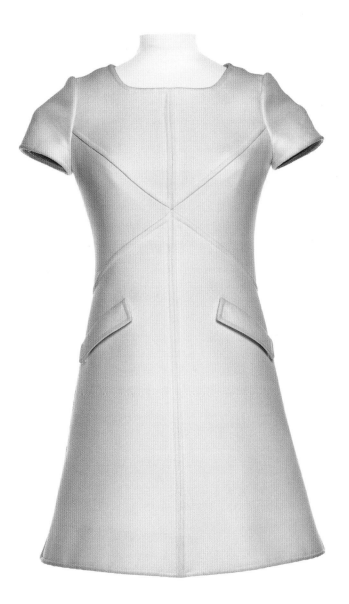

The Courrèges designs are ... very fresh and ... white is predominant, for an absolute newness; this deliberately youthful fashion, with its schoolgirl, sometimes childish, references.... From Chanel to Courrèges the "grammar" of the times has changed: the timeless chic of Chanel tells us that a woman has lived (and lived well), and the obstinately "new" of Courrèges that she is going to live.

Roland Barthes, "Le match Chanel-Courrèges," article for **Marie Claire**, September 1967, reproduced in **Le Bleu Est à la Mode Cette Année**, Paris: IFM Éditions, 2000

COURRÈGES

Dress, 1967, Spring–Summer
collection (haute couture).
Off-white stitched wool mix.

1967

The woman of tomorrow will
be ... incontestably superior
to man. She is the woman
for whom I design clothes.
My designs are my weapons.

Paco Rabanne, internal document for the couture house, 1967

PACO RABANNE

1968

Minidress, 1968,
Spring–Summer collection
(haute couture).
Alternately hammered
and smooth aluminum
plates, aluminum links.

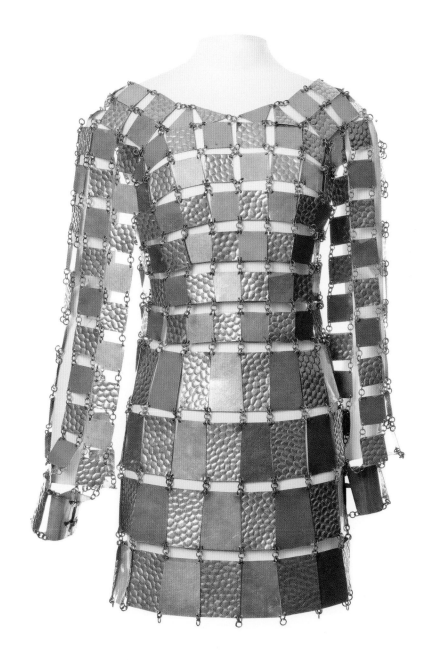

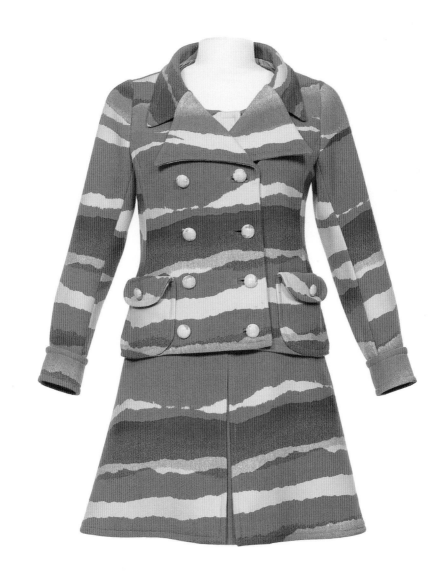

Look! Who said
there are only colors?
There are also tones!

Declaration by Diana Vreeland, American fashion journalist and editor, 1969

**EMANUEL
UNGARO**

Jacket and minidress, 1969,
Fall–Winter collection
(haute couture).
Printed woolen fabric.

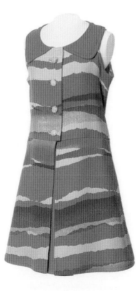

1969

Paris has become a respectable elderly lady longing to be ravished, so I ravished her.

Jacques Esterel, "Leurs robes à eux," report broadcast during the TV program
Dim Dam Dom, March 16, 1970

1970

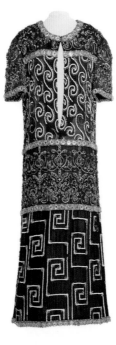

JACQUES ESTEREL

Man's Sumérienne robe,
one of a pair of unisex robes,
1970 (haute couture). Crepe
silk georgette, embroidery
with sequins, tube beading,
beads, rhinestones, buttons,
and cabochons, silver braid
appliqué.

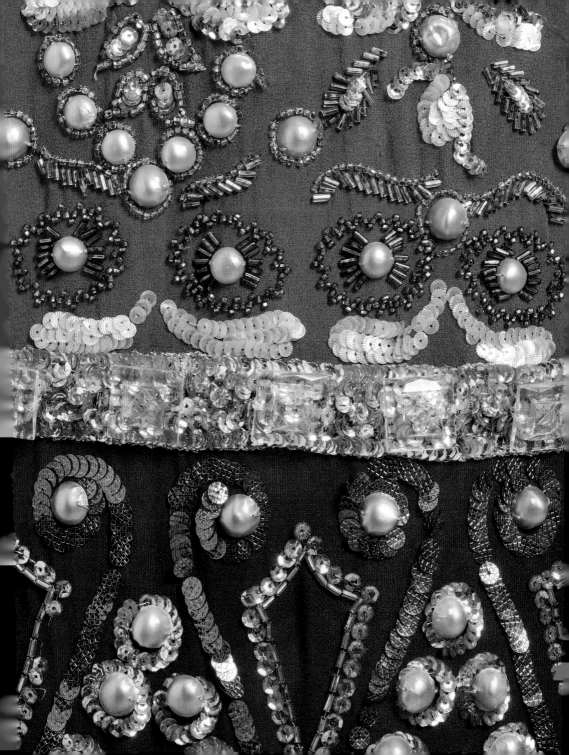

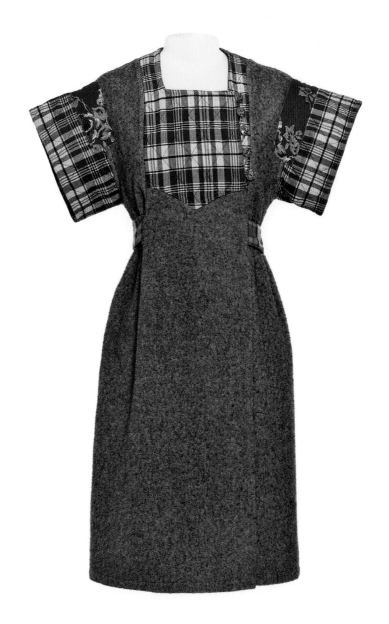

No Japanesey influences. No Oriental bazaar-style folklore. No Saint-Germain-des-Prés exotic chic. Its inspiration comes from far, far away. It is subtle, never obvious. Suggested, never shown.

Mariella Righini, **Le Nouvel Observateur**, April 1970

KENZO
Jap line

Wrap dress, 1971, Fall–Winter collection (ready-to-wear). Wool felt, quilted and stitched tartan cotton, printed cotton.

1971

To counterbalance sportswear, and trousers, and the return to classicism— albeit in an updated form—in short, to counterbalance the stricter look of their everyday wardrobe, this year women want dresses.

Gap, September 1972

1972

GIVENCHY

Evening ensemble, 1972, Spring–Summor oollootion (haute couture). Wrap top in white organdy, white silk taffeta, skirt in navy blue silk gazar.

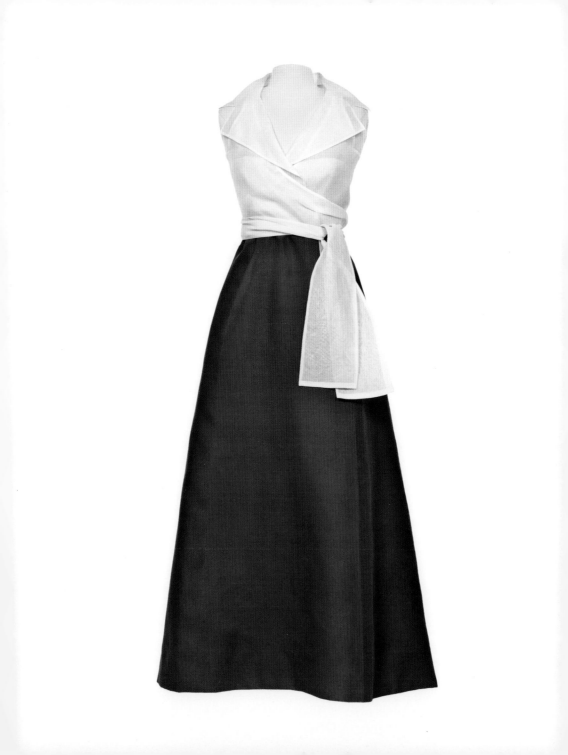

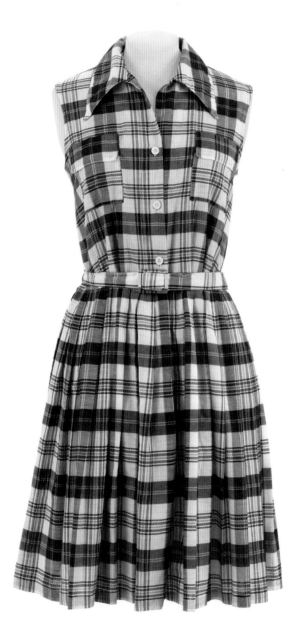

The dress is back; the real dress, not the miniskirt-cut-out-of-a-dishcloth, which might have looked great on leggy eighteen-year-olds but didn't do justice to forty-something grandmothers—who abound these days—or to all the delightful women over and above.

Paul Guth, "Le retour," **Midi Libre**, 1973

JOSSELYNE
for Monoprix

Dress, 1973 (ready-to-wear).
Checkered toile with white,
blue, green, and red polyester
threads, cotton.

1973

Fresh, graceful, sophisticated, soft,
in cheerful or subdued colors, fun and
truly indispensable, "the little dress"
has made quite an entrance this season.

"Enfin voici des robes," **Mlle Âge Tendre**, November 1974

1974

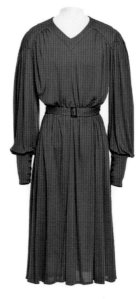

JEAN MUIR

Dress, 1974 (ready-to-wear).
Fuchsia rayon jersey knit.

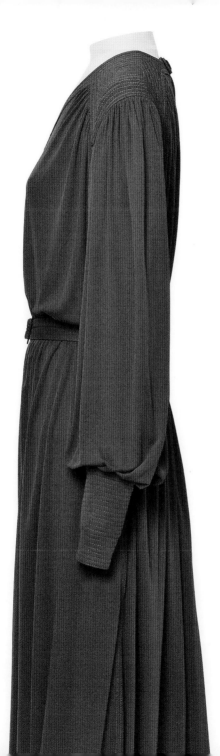

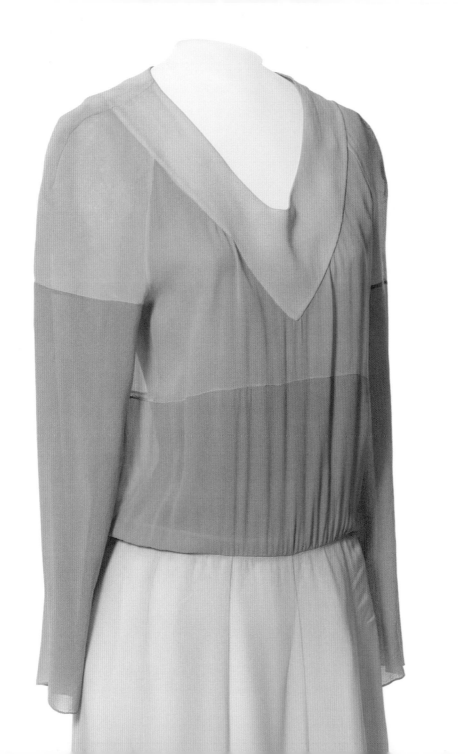

My uncle Jules saw my line of work as a desperate attempt to be understood by women.... He was fascinated by the uselessness of my art. He took me for a new kind of swindler.

Louis Féraud, **L'Été du Pingouin**, Paris: Julliard, 1975

LOUIS FÉRAUD

Dress, 1975 (haute couture).
Crepe georgette.

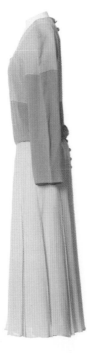

1975

It'll be the big fashion in fall. . . .
Girls will wear full capes
that will give them a mystical
and fascinating air.

"Des capes pour des filles mystérieuses. . . ," **Mode International**, no. 14, 1976

GIVENCHY

1976

Evening ensemble (dress and
cape), 1976 (haute couture).
Silk organza with a floral
print, purple ribbon piping.

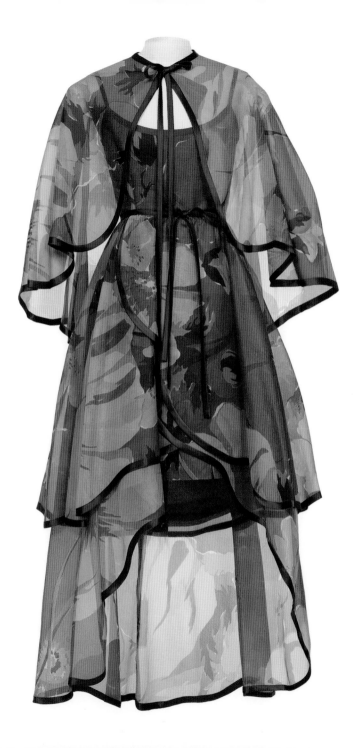

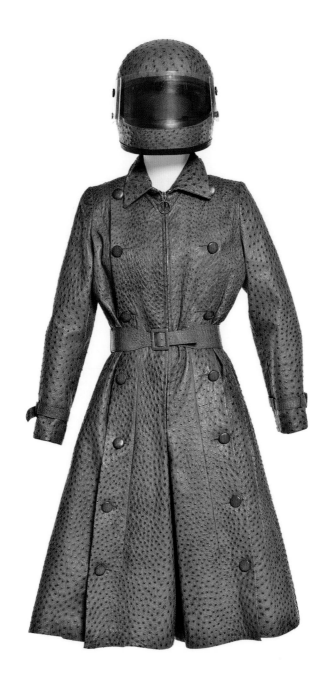

Couture has always looked to distant horizons for its inspiration.... Fortunately, exoticism in Paris has never been a form of disguise; and French couturiers through the history of couture have always succeeded in interpreting it... to such an extent that they made Parisian dresses out of it.

Pierre Balmain, interview broadcast on French TV channel TF1, July 25, 1976

PIERRE BALMAIN

Suit-coat, 1977, Winter collection (haute couture). Dyed ostrich skin, silk taffeta.

1977

Nothing defines fashion better than the adjective "old-fashioned," which is its opposite.

Editorial, **Mode International**, January 1978

1978

SOULÉIADO

Dress, c. 1978
(ready-to-wear).
Cotton toile printed with
rose motifs over brown
with blue dots.

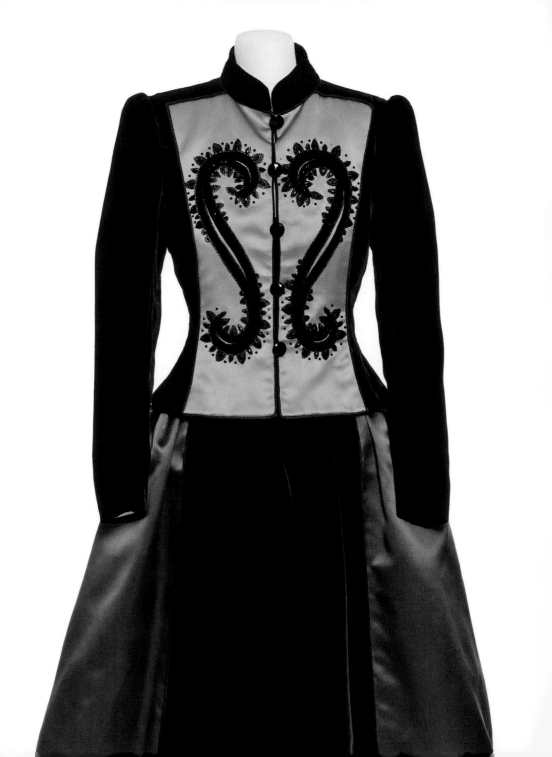

In a season where SHAPE has become the most important trend coming out of Paris, YSL goes against the current. Privately, Yves St. Laurent says, "It's time for me to be quiet and rework my own classics." After all these years, the pause is essential and this moment is right for quiet fashion. Why should there be a new idea every minute?

Marian McEvoy, **Women's Wear Daily**, February 2, 1979

YVES SAINT LAURENT

Evening ensemble, 1979, Fall–Winter collection (haute couture). Black silk velvet and embroidered silk satin.

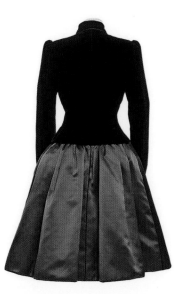

1979

The designer was inspired
by the natural elements:
the sun and the cracked earth,
and he couldn't help thinking
of Ben Hur in certain
gold-studded leather designs.

L'Officiel de la Mode, February 1980

THIERRY MUGLER

1980

Evening gown, 1980,
Spring–Summer collection
(ready-to-wear). Brown
silk crepe, copper body
armor, leather strap
fastenings at the back.

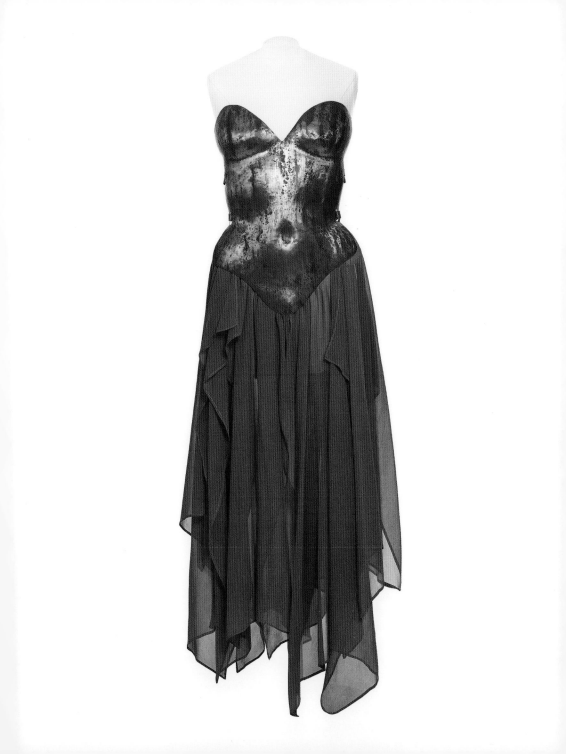

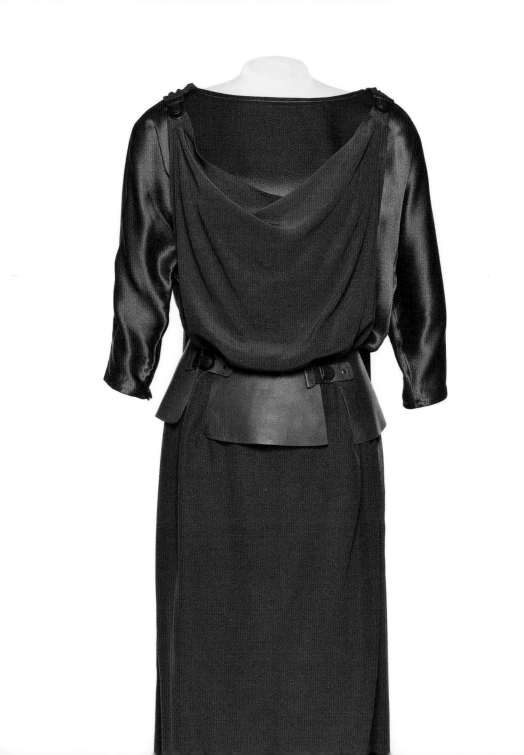

Jean Paul Gaultier will use anything that takes his fancy, in a neo-Dadaist spirit with a dash of comic-strip culture: "I am a fan of the Belgian school, and I'm particularly fond of Jacques Martin's *Alix*. I drew inspiration from it for my peplum designs."

Marylène Delbourg-Delphis, "Branchées pas branchées," **Le Chic et le Look**, Paris: Hachette, 1981

JEAN PAUL GAULTIER
for Kashiyama

Day dress, 1981, Fall–Winter collection (ready-to-wear). Viscose satin, leather belt.

1981

You always come up against the same question: will it catch on?

"Si jeunesse m'était contée," **Péplos**, March 1982

1982

YOHJI YAMAMOTO

Day dress, 1981–82,
Fall–Winter collection
(ready-to-wear).
Khaki wool muslin.

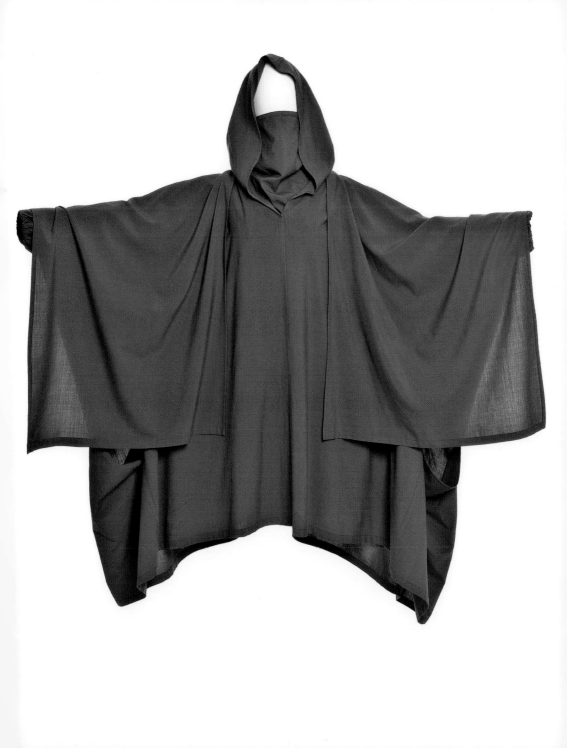

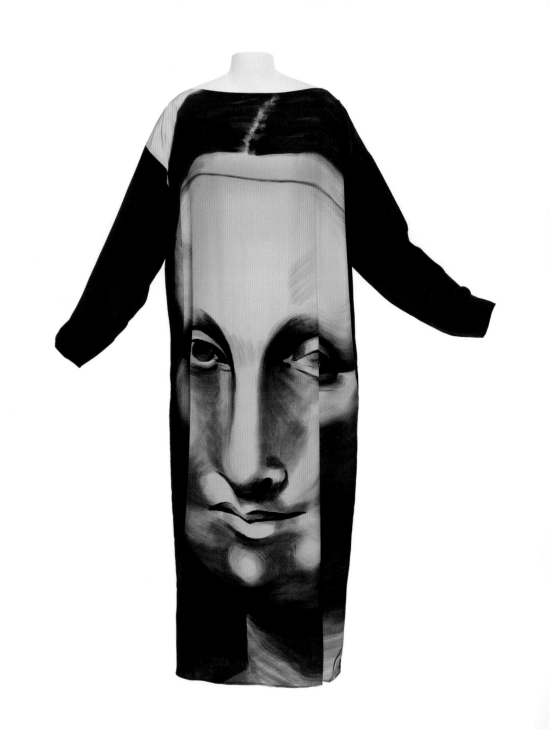

Castelbajac hungrily takes in all the new images: rock music, comic books, modern expressionist art, photos, which he collects. Many of his garments proudly display large-size portraits: from Mickey Mouse to Jackie Kennedy or Louis XIV.... Castelbajac seems to be the only one who is commissioning artists once again for his designs, as in the heyday of haute couture.

Actuel, May 1983

**JEAN-CHARLES
DE CASTELBAJAC**
for Ko and Co

La Joconde [Mona Lisa]
dress, 1983, Fall–Winter
collection (ready-to-wear).
Printed silk crepe.

1983

Wearing a Beretta design has become
a means of self-expression, because
the true strength of the garment,
according to this grande dame of fashion,
is to show on the outside who you are
on the inside.

La Presse, April 3, 1984

1984

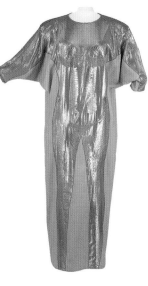

ANNE MARIE
BERETTA

Astre dress, 1984,
Fall-Winter collection
(ready-to-wear).
Pale pink woolen fabric,
gold and pink lamé appliqué,
embroidered salmon-pink
and silver-colored sequins.

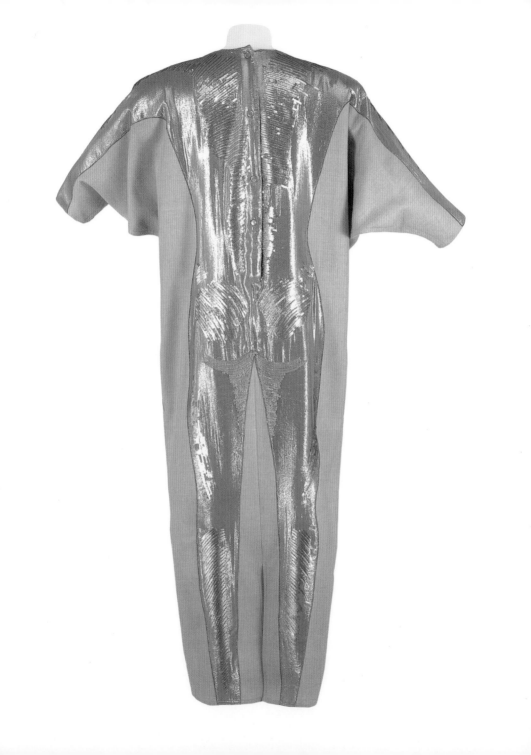

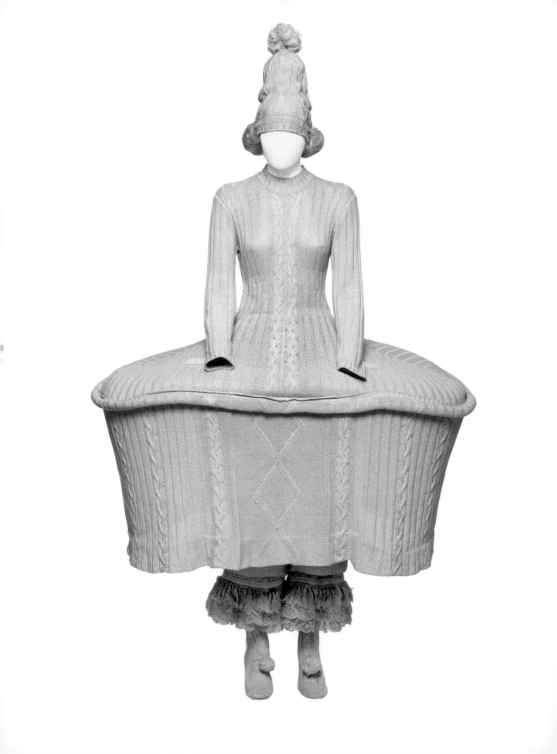

Jean Paul Gaultier may or may not appeal, but he always surprises us with humor. Undeniably.

"Paris, succès des nouveaux classiques," **L'Officiel de la Mode**, February 1985

JEAN PAUL GAULTIER

Dress and pants ensemble (theater costume), 1985. Ivory cotton knit, elastane waist, oval steel hoop.

1985

For this collection, I wanted to pay tribute to the house of Patou, to everything it represents. I also had a desire to create exotic *tragediennes*, laid bare yet proud. I drew inspiration also from certain photos by Lartigue depicting over-attired flower-women walking in the park, and Renoir paintings like *The Swing*, which gave me ideas for some dresses.

Christian Lacroix quoted by Javier Arroyuelo, "Jean Patou par Christian Lacroix," **Vogue**, March 1986

JEAN PATOU
by Christian Lacroix

Lido Buto evening ensemble, 1985–86, Fall–Winter collection (haute couture). Chantilly lace, embroidery with sequins, faceted beads, copper, rhinestones, and cabochons, black silk velvet skirt, taffeta and silk organza voile draping.

1986

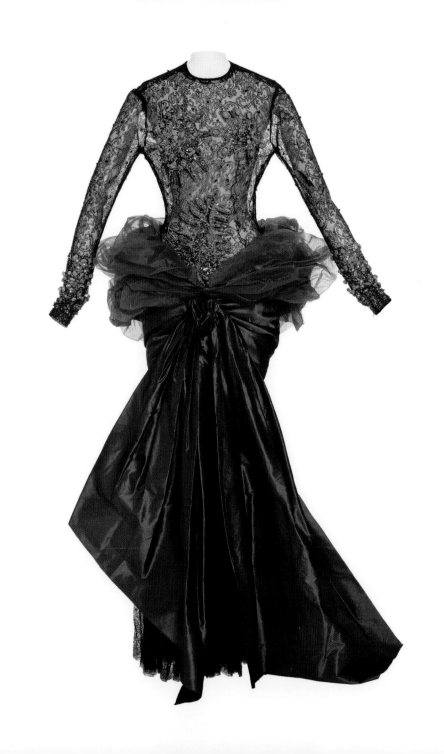

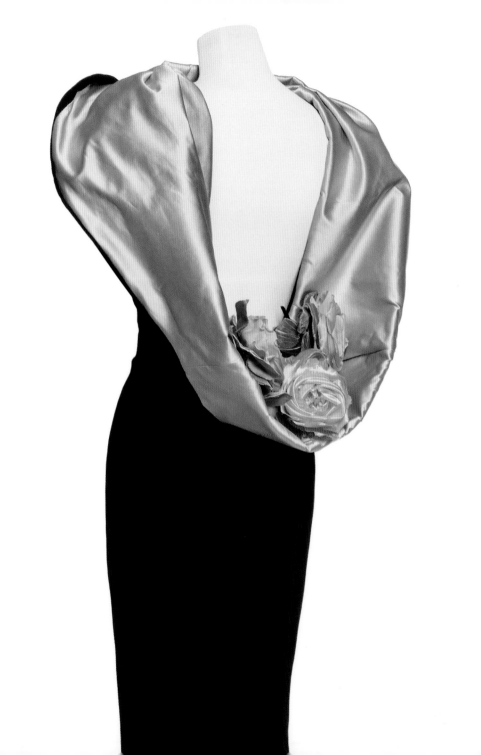

They said Haute Couture was anachronistic, outdated, sad. It was an uncongenial toast in a luxury hotel, a glass of flat champagne, an elderly lady shuffling her way into a museum. Snubbed by journalists, betrayed by society women, it was paraded twice a year in the wretched salons of the old world of Parisian chic.... "What youth!" cried *Vogue* in September '87.

Laurence Benaïm, "Les riches heures de la couture," **L'Année de la Mode, 87-88**, Lyon: La Manufacture, 1988

THIERRY MUGLER

Embarquement Immédiat [Immediate Embarkation] evening gown, 1987, Fall-Winter collection (ready-to-wear). Black silk velvet, pink silk satin, silk roses.

1987

Haute Couture 88
is all about impertinent suits.

Vogue, September 1988

1988

CLAUDE
MONTANA

Skirt suit, c. 1988–89
(ready-to-wear).
Draped red wool.

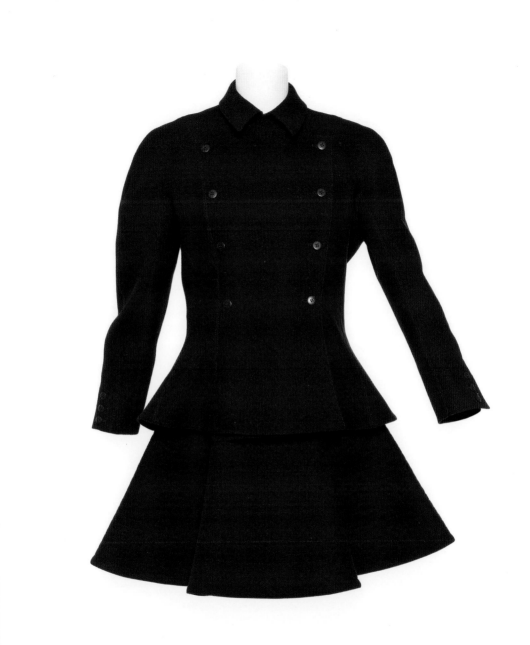

What is unfolding before our eyes
is a kind of performance, a kind of
enchanting magic. It's in the music,
the lighting, the tall, slender girls swaying
as they move; it's in the dress that catches
a little of the light from the thousands
of camera flashes.

"Lever de rideau sur les collections automne-hiver 89," **La Presse**, March 21, 1989

PATRICK KELLY

Dress, 1989, Fall–Winter
collection (ready-to-wear).
Black wool jersey, appliquéd
plastic and silver metal buttons.

1989

With a few exceptions, the predominant ambience is that of a residential college where students endlessly pore over the cuts of a certain Yohji Yamamoto, whose asymmetrical forms, single-button suits, and dresses with irregular panels are among the most copied designs of the season.

L'Officiel de la Mode, July 1998

1990

YOHJI YAMAMOTO

Dress, 1990, Fall-Winter collection (ready-to-wear). Woolen fabric.

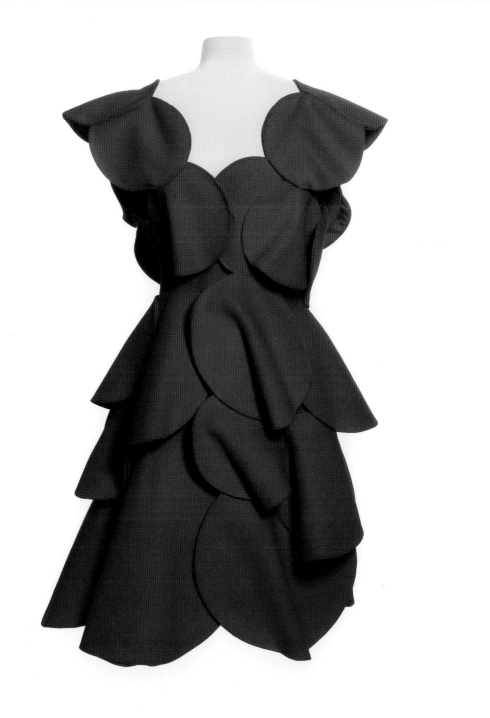

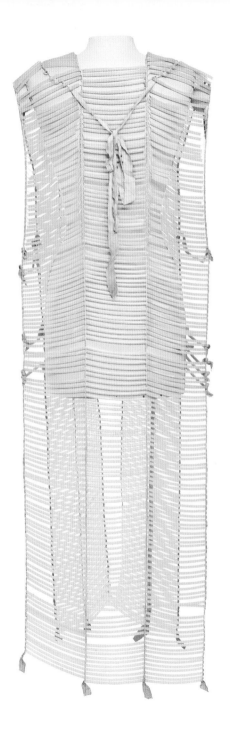

Gaultier, Helmut Lang,
Yohji Yamamoto, Romeo Gigli,
and *tutti quanti* delight here,
irritate there, but leave no one
indifferent. They are tireless
when it comes to digging
for new ideas.

M. B., "De cuir noir et d'or pur," **L'Humanité**, March 20, 1991

HELMUT LANG

Coat dress, 1991,
Spring–Summer collection
(ready-to-wear). PVC tubes,
beige chamois cords.

1991

Let's hone our desires so that fashion brings us its many-splendored pleasures once more. Let's battle the ambient gloom, and go for what is unique, rare, exclusive.... Let's applaud those who, like Christian Lacroix..., offer us flamboyant collections to behold like paintings.

"Vive l'exception," **L'Officiel de la Mode,** March 1992

1992

CHRISTIAN LACROIX

Mademoiselle Hortensia evening gown, 1992, Fall-Winter collection (haute couture). Patterned iridescent black twill, black faille bow, black silk taffeta flounce.

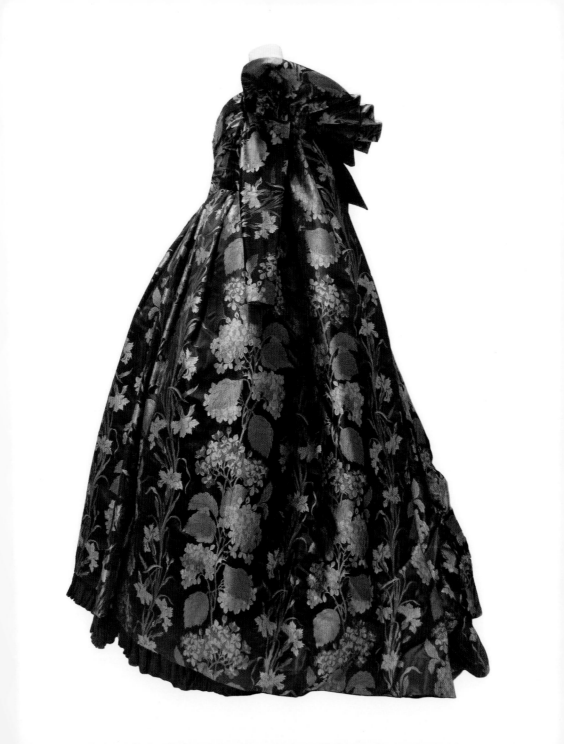

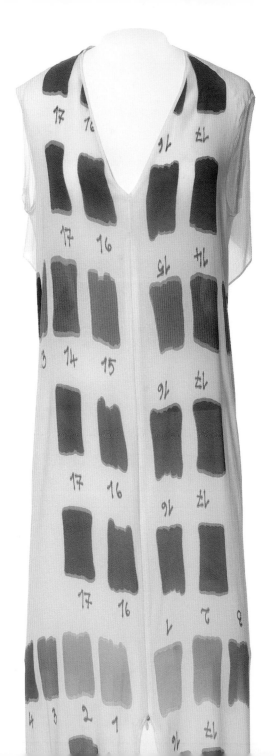

"We are moving with our times while remaining faithful to the spirit of couture. Standardized clothing is not our thing." And with good reason. Their style is authentic and focused, shunning the "recycling" trend that's very fashionable today.... Their hallmark? Barely hinted-at seams thanks to cutting from one single piece.

Michèle Leloup, "Les purs de l'épure," **L'Express**, November 4, 1993

MARIOT CHANET

Dress, 1993, Spring–Summer collection (ready-to-wear). Handpainted elasticated silk chiffon.

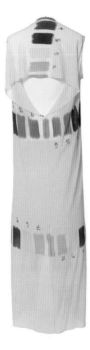

1993

For as long as I have known him,
he has gathered and collected odds
and ends discarded by others—from bits
of cloth to pieces of material, from fabric
samples to fragments of garments—
which only he knew how to assemble
into magnificent gowns.

Marie-Thérèse Leccia on the designer, internal document from the couture house
regarding the Composition Indéfinie collection

1994

DANIEL JASIAK

Dress, 1994 (ready-to-wear).
Pieces of dark gray ribbed
cotton velvet.

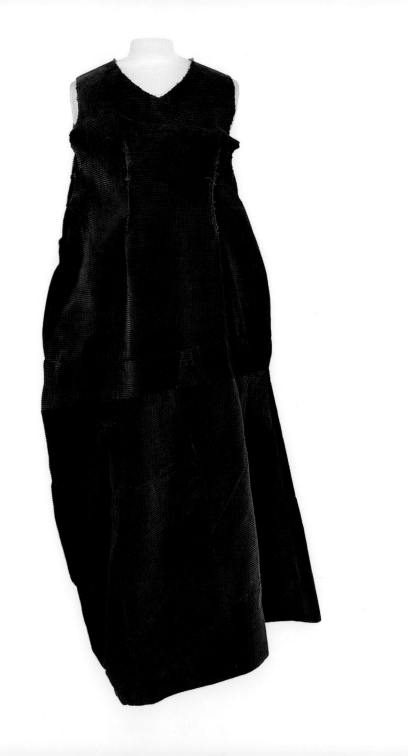

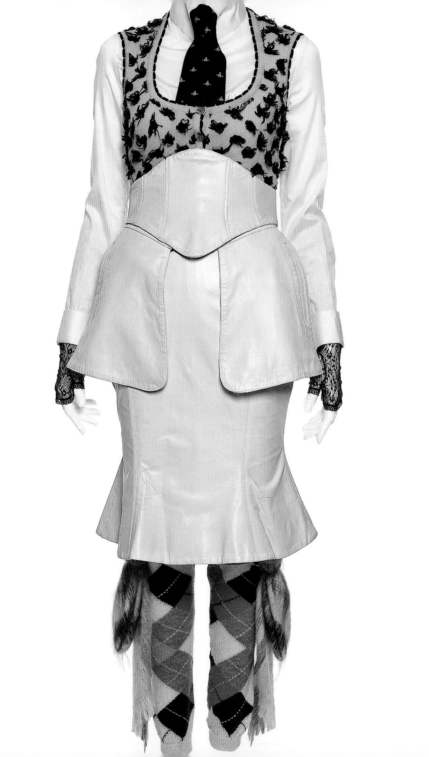

Whether used for a dress, a skirt, or a jumpsuit, leather is the femme fatale's ultimate weapon.

Femme, October 1995

**VIVIENNE
WESTWOOD**

Waistcoat, dress-shirt,
and skirt ensemble, 1995,
Fall–Winter collection
(ready-to-wear). Woolen knit,
cotton toile, and white leather.

1995

Four or five of my clients set the tone. They had chic.... I was thinking of Arletty and her expression *"vierge de toute décoration"* [untouched by any decoration]. I invented a slim, no-frills silhouette.

Azzedine Alaïa in an interview by Xavier de Jarcy, "J'ai appris la mode avec les femmes," **Télérama**, October 5, 2013

AZZEDINE ALAÏA

1996

Evening gown, 1996, Spring–Summer collection (ready-to-wear). Black elasticated viscose openwork knit, embroidery with beads and sequins.

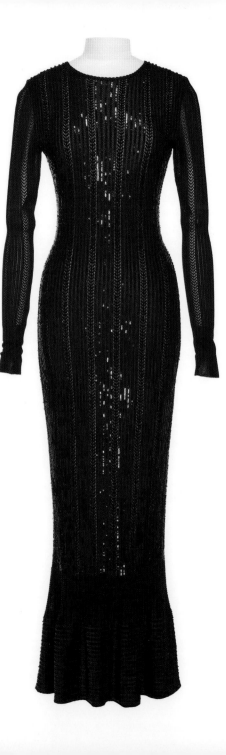

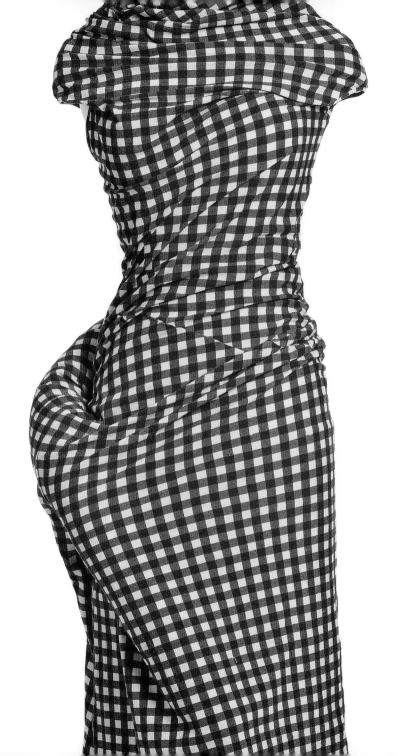

Every Rei Kawakubo show is a bravura piece.... For example, a red dress with restrained arms and an enormous bump starting at the left shoulder and descending into a great bulge at the right elbow and hip. You can laugh, and liken it to a Quasimodo rag, or you can just let your jaw drop, shrug off your prejudices, and find it simply strange and beautiful.

Loïc Prigent, "La cap-hornière de l'ourlet," **Libération**, January 22, 1998

COMME DES GARÇONS

Bump dress, 1997,
Spring–Summer collection
(ready-to-wear).
Printed synthetic jersey,
polyester wadding.

1997

I feel that we are entering a period of our own Belle Epoque as we approach the end of the millennium, with a return to romanticism and elegance.

John Galliano quoted by Stephen Gan, "The Return of La Belle Epoque," **Harper's Bazaar**, March 1998

1998

CHRISTIAN DIOR
by John Galliano

Stour Head evening ensemble, 1998, Spring–Summer collection (haute couture). Gilded and handpainted quilted silk brocade, aged embossed silver lamé, silk chiffon embroidered with silver metallic threads and rhinestones.

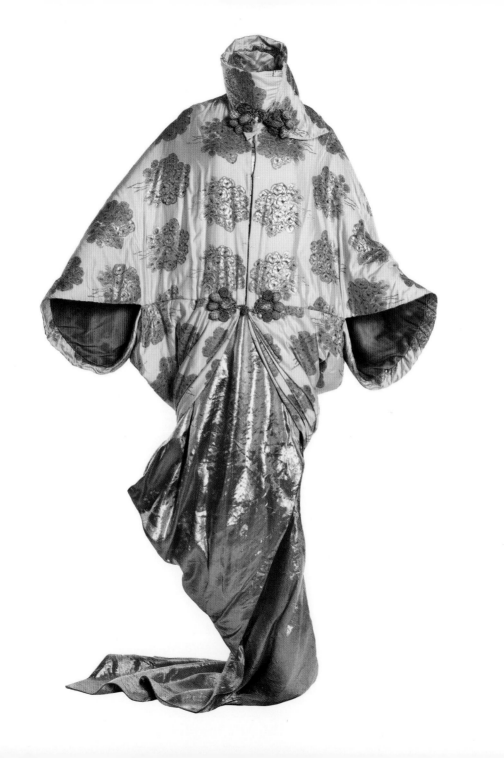

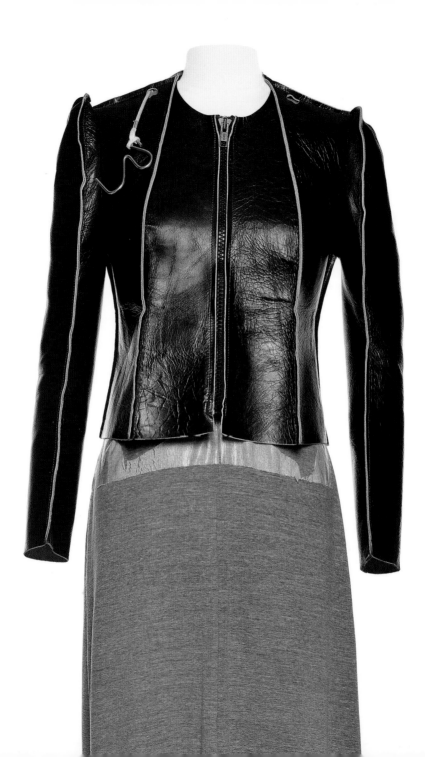

When people talk about the Flemish
school, it's no longer just the Van Dycks,
Jordaens, or P. P. Rubens that come
to mind, but also the talented designers
trained at the Antwerp Academy of
Fine Arts.

Jalouse, November 1999

MARTIN MARGIELA

Jacket and dress ensemble,
1998-99, Fall-Winter
collection (ready-to-wear).
Leather and partially
laminated cotton jersey.

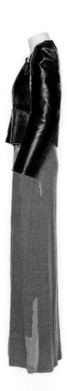

1999

Luxury and style, two notions that are back in fashion thanks to haute couture, which has woken up.... Talented young designers have restored its former glory, and brought in a new image of woman.

Frédérique Mory, "La mode est un éternel recommencement," **Madame Figaro**, September 9, 2000

2000

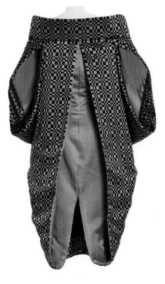

GIVENCHY
by Alexander McQueen

Dress, 2000, Fall-Winter collection (haute couture). Two-tone black and orange patterned satin.

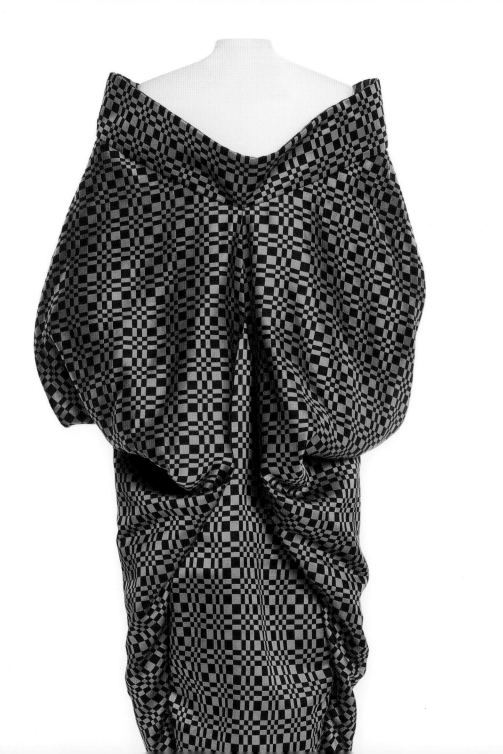

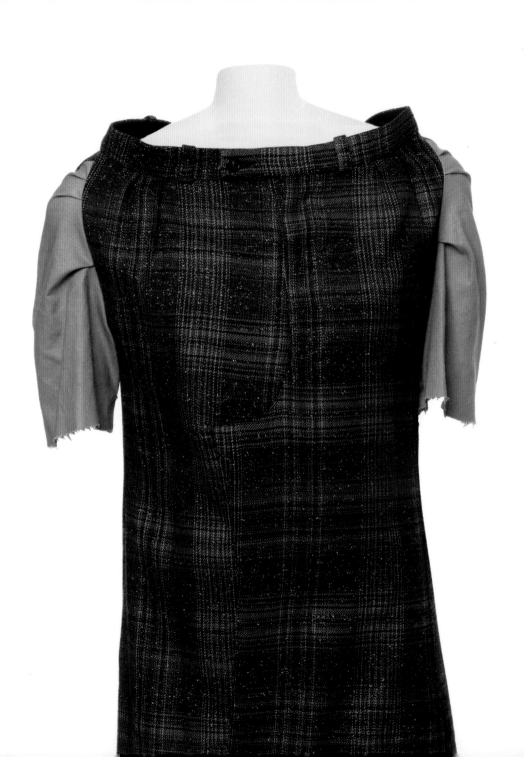

A highly feminine reinterpretation of masculine standards, custom-adjusted to women's changing moods. This is the intention of Anne Valérie Hash's designs. Sophisticated fashions with personality.... "It's the story of a little girl who tries on her father's clothes."

Marjorie Sylvain, "Anne Valérie brouille les cartes du jeu féminin-masculin," **Jalouse**, October 2001

ANNE VALÉRIE HASH

Dress, 2001-2, Spring–Summer collection (ready-to-wear). Cut from a pair of men's trousers in mottled brown, black, khaki, and pink- and orange-beige tartan wool.

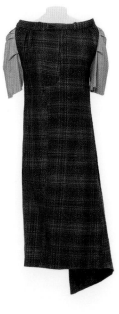

2001

Thanks to his amiability and
professionalism, [Alber Elbaz]
has become a favorite with women
fashion writers and buyers worldwide.

Patrick Cabasset, "Nouvelles têtes," **L'Officiel de la Mode**, June 2002

LANVIN
by Alber Elbaz

2002

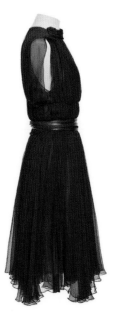

Dress, 2002, Winter collection
(ready-to-wear). Dark red
pleated silk chiffon,
leather belt.

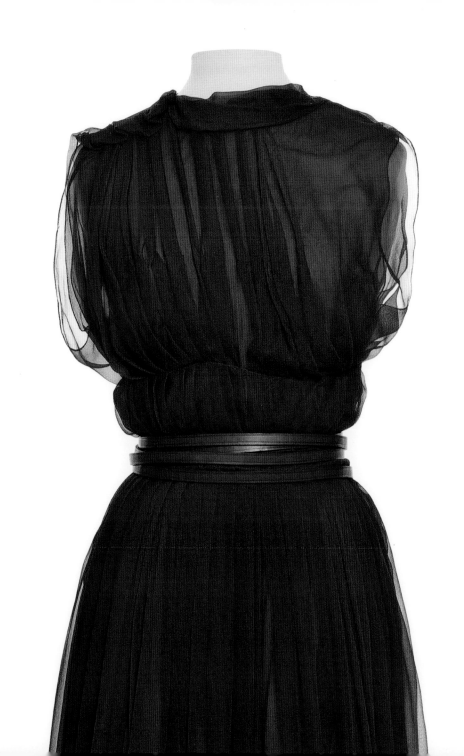

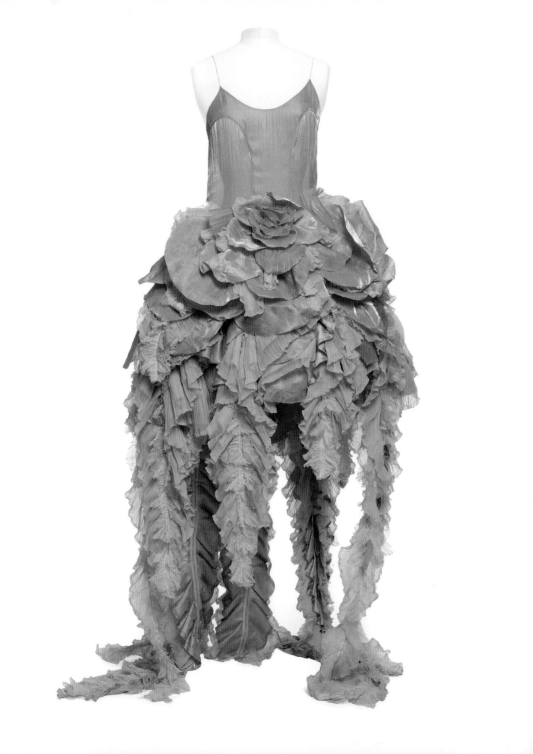

To be a woman, a real woman. Phew! The ambient androgyny of the 1990s is finally a thing of the past.

Catherine Roig, "Nos envies 2003," **Elle**, January 13, 2003

ROCHAS
by Olivier Theyskens

—————————

Evening gown, 2003–4,
Spring–Summer collection
(ready-to-wear).
Pink synthetic pleated
and embossed taffeta,
pale pink embossed chiffon,
lace shirring, satin ribbons,
and pink lamé frills.

2003

Lotus flowers adorning chiffon gowns, painted silks, golden plumes with swirls of organza: the house of Dior and its couturier John Galliano set the tone with the mysteries and divinities of ancient Egypt,... a reminder that Dior rhymes with *or* [gold].

S. D., **ladepeche.fr**, January 20, 2004

2004

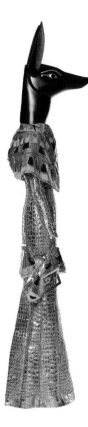

CHRISTIAN DIOR
by John Galliano

Evening ensemble, 2004, Spring-Summer collection (haute couture). Gold lamé, appliquéd gilded and painted python skin.

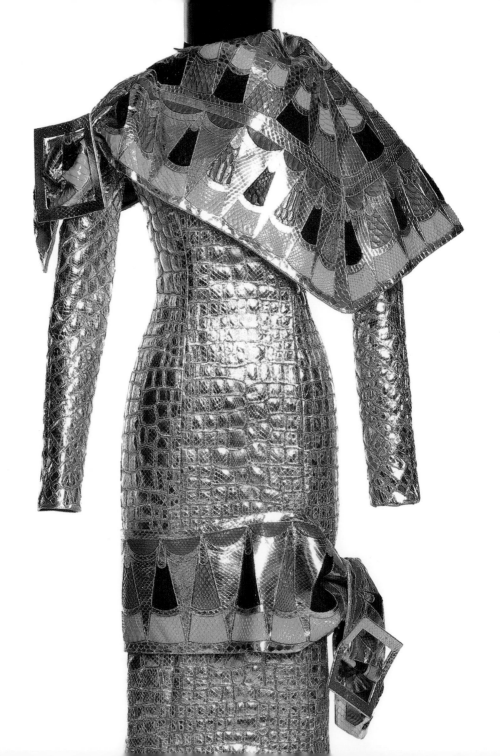

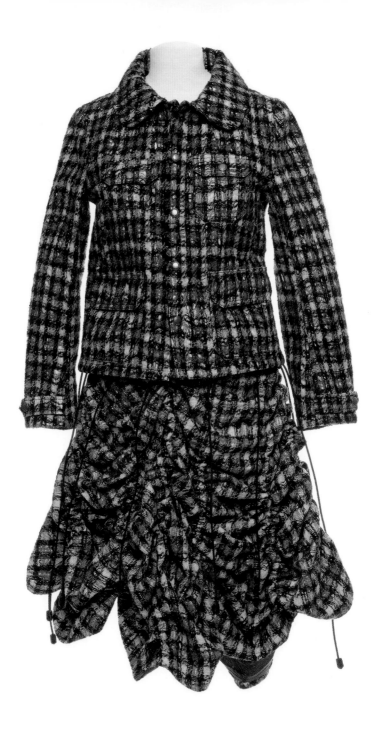

Complex references, a mixture of styles,
a rock 'n' roll atmosphere and '50s couture
make the Junya Watanabe collection
a melting pot of trends.... A whole
history of fashion was on the podium.

L'Officiel 1000 Modèles, no. 53, 2005

JUNYA
WATANABE

Skirt suit, 2005, Fall–Winter
collection (ready-to-wear).
Wool-backed coated
nylon knit.

2005

When you find that pure shape, I don't
see the need to change it every six months
because it's summer or winter.... It's
difficult in a society that is so reliant
on change, and some use the charge
of continuity as a form of criticism,
doing the same things.

Véronique Branquinho, interview published online on the blog **Fashion Interviews**,
July 3, 2006

**VÉRONIQUE
BRANQUINHO**

Evening gown, 2005–6,
Fall-Winter collection
(ready-to-wear).
Emerald green velvet.

2006

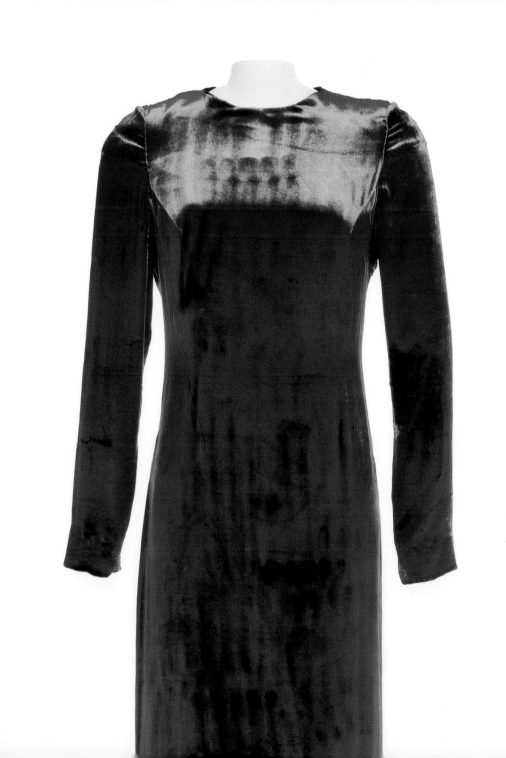

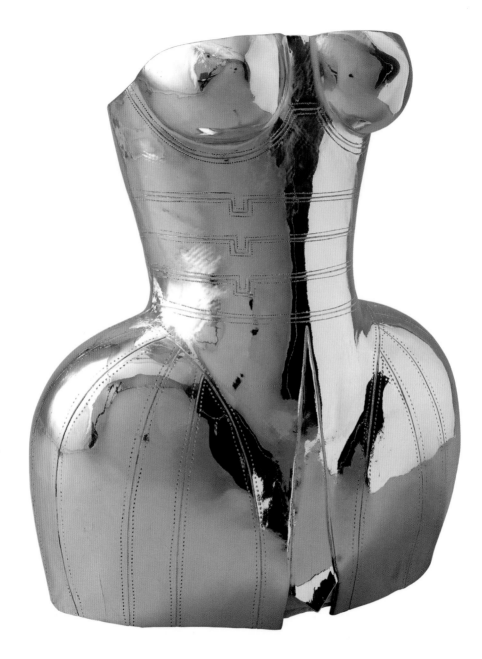

Futuristic retro design and metallic elements create a woman-as-armor. A kind of chic android, like something out of *RoboCop*. A look back to the future as imagined in the 1980s, inspired by the 1940s. Get the picture?

Jérôme Hanover, Sylvie Maysonnave, Patrick Cabasset, **L'Officiel Supplément**, no. 912, 2007

DOLCE & GABBANA

Evening gown, prototype created by Hubert Barrère, 2007, Spring–Summer collection (ready-to-wear). Chromed lambskin, polyester resin, organza.

2007

A delicious treat. The Sonia Rykiel show was a cherry on the cake of the collections. The very image of light-hearted Parisian chic. Wrapped in coat dresses enfolding them like giant petals, the models were smiling at last!

Vanessa Zocchetti, **elle.fr**, March 5, 2007

SONIA RYKIEL

2008

Dress, 2008, Spring–Summer collection (ready-to-wear). Ivory cotton jersey with trompe-l'oeil motifs.

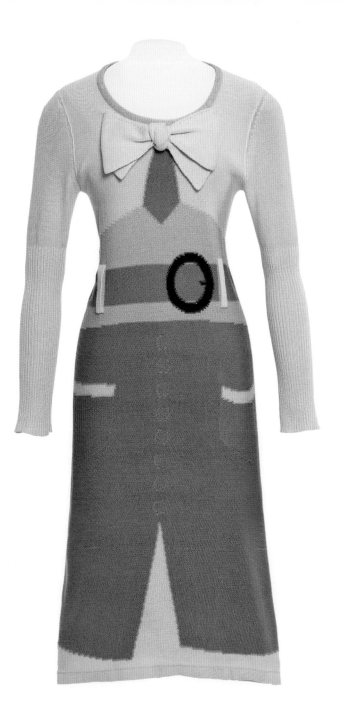

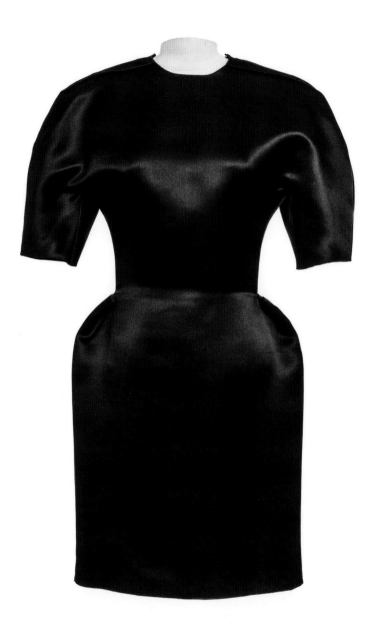

No unnecessary waffle here, it's back to clothing basics. In so doing, Alber is catering to women who want to dress well, not wear fancy dress, women who refuse to let their outfit compete with them.

Virginie Mouzat, **madame.lefigaro.fr**, on the Spring–Summer 2009 ready-to-wear fashion show

LANVIN
by Alber Elbaz

Dress, 2009, Fall–Winter collection (ready-to-wear). Black silk satin.

2009

No risk of bad taste here. The collection is spot-on, sophisticated, and exquisite: all in ivory and black satin and yet with a genuinely modest feel, with deftly cut volumes in the back of the jackets and striped sweaters; it is truly elegant in its asymmetrical lines.... Bouchra Jarrar, a budding brand that's set to deliver fast returns on investment.

Paquita Paquin, "The Timely Bouchra Jarrar Show," **puretrend.com**, February 1, 2010

2010

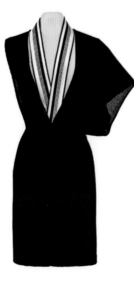

BOUCHRA JARRAR

Dress, 2010, Spring–Summer collection (ready-to-wear). Wool crepe, crepe de chine, and silk satin.

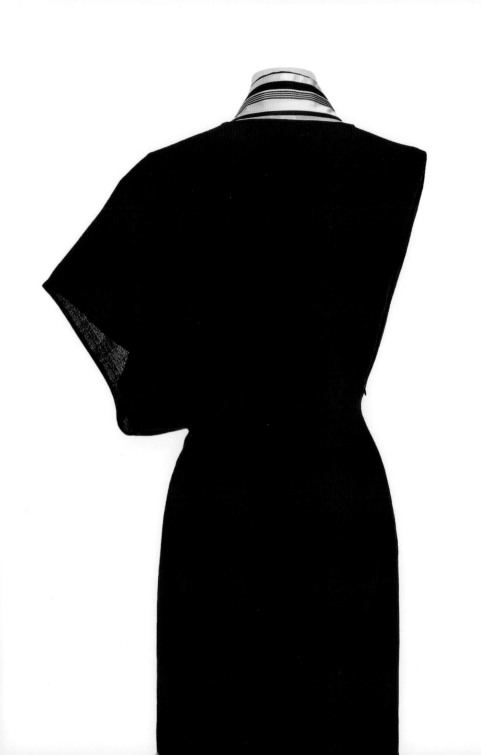

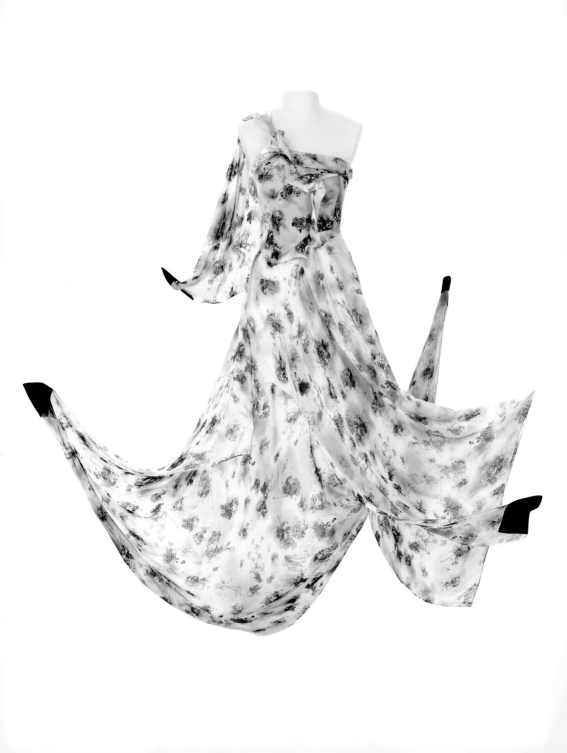

At the crossroads of fashion, architecture, and design, the clothes Hussein Chalayan has been creating for seventeen years are in a class of their own. [This designer] continually surprises us with his avant-garde, intellectual, and politically committed fashions.

Jean-Marie Dubois, "Expos Musées," **Paris Capitale**, October 2011

HUSSEIN CHALAYAN

Dress, 2011, Spring–Summer collection. Silk.

2011

Not quite knowing what you were seeing was part of the delight, an experience which threw the audience into a rare state of purely visual response, where the usual foreground preoccupations about message, wearability, and trends dropped away, and the brain clicked onto a trancelike level of just looking.... It called up a sense of childlike freedom and enjoyment—memories, maybe, of spontaneous preschool play with fuzzy felt shapes, paper cutouts, and the paintbox.

Sarah Mower, **vogue.com**, March 3, 2012

COMME DES GARÇONS

Coat dress, 2012, Fall–Winter collection (ready-to-wear). Topstitched and glued polyester felt.

2012

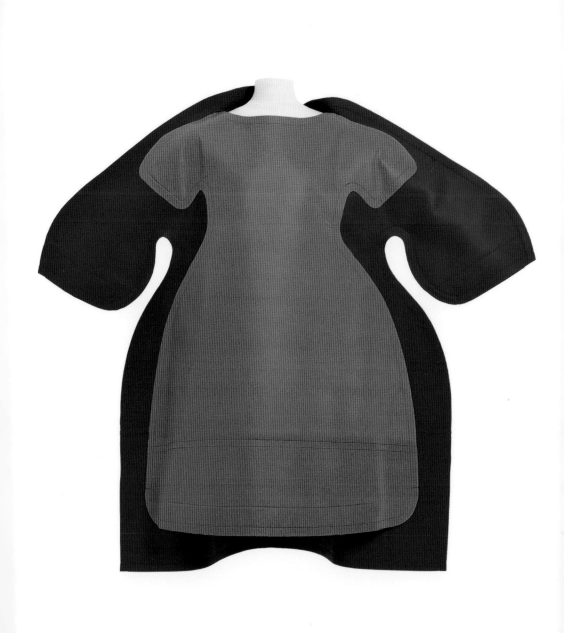

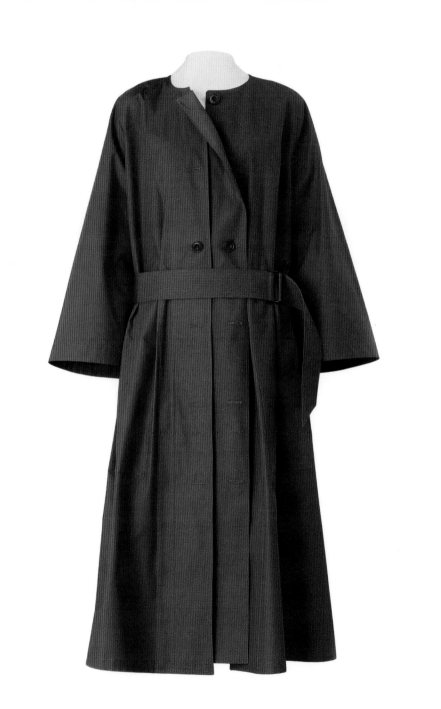

Christophe Lemaire loves loose
silhouettes inspired by the '20s
with a touch of natural Asian charm.
His timeless wardrobe pieces speak to
the intelligent, authentic woman
who shuns the dictates of throwaway
fashion and the latest must-haves.

Charlotte Langrand, "Les vêtements sont ses amis," **Le Journal du Dimanche**,
February 24, 2013

LEMAIRE

Coat dress, Lemaire
wardrobe staple, renewed
each year in various colors.
Cotton poplin.

2013

This is an incredible experience for us. It's the beginning of an adventure, something real. We would like to thank the jury for this wonderful opportunity that will contribute to the development of our brand.

Arnaud Vaillant and Sébastien Meyer on receiving the ANDAM (Association Nationale de Développement des Arts de la Mode) award in July 2014

COPERNI FEMME

2014

Short "3D" pleated dress, 2014. Bonded cotton fabric, pleats made of a patchwork of ten vertical bands.

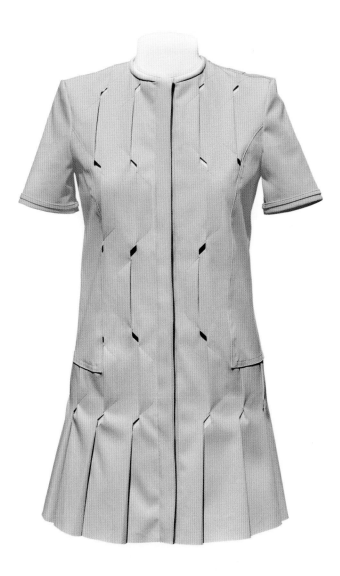

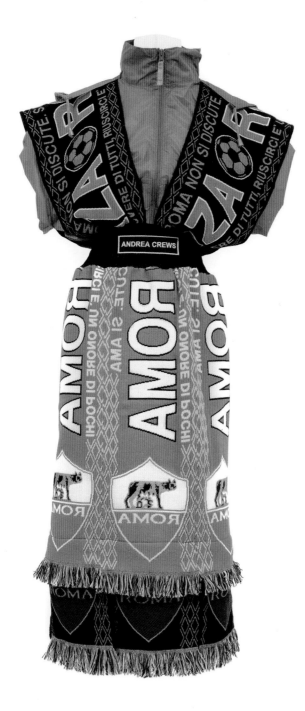

I love ordinary people in the street—popular cultures. Since everything looks alike these days, I find blurring the lines exciting. By setting soccer scarves into this windbreaker, I have created a hybrid piece that's a cross between a hooligan cocktail dress and a djellaba from the future. Reinterpreting the rules means regaining power.

Declaration by Maroussia Rebecq, designer and founder of the
Andrea Crews collective, 2015

ANDREA CREWS

Dress, 2015.
Reinterpretation
of soccer scarves
in jacquard,
windbreaker in
high-tech fabric.

2015

With the exception of those on pages 214, 218, 221, 222, and 223, all of the dresses featured in this book are held at Les Arts Décoratifs.

Those on pages 22, 24, 29, 30, 34, 36, 39, 41, 42, 44, 48, 50, 52, 54, 56, 60, 63, 67, 68, 72, 75, 78, 80, 82, 85, 87, 94, 97, 98, 101, 102, 106, 109, 117, 124, 129, 132, 134, 138, 146, 153, 154, 181 are from the collections of the UFAC (Union Française des Arts du Costume), held at Les Arts Décoratifs. The dress on page 158 is a permanent loan from the Centre National des Arts Plastiques - Ministère de la Culture et de la Communication, 1986.

The dresses held at Les Arts Décoratifs were acquired thanks to the generous support and gifts of the following people:
Gift of Madeleine Vionnet, 1952: pp. 29, 34, 36
Gift of Mme Darmon, 1954: p. 39
Gift of Mme Julliard, 1957: p. 68
Gift of Christian Dior, 1958: p. 87 / 2005: p. 189 / 2006: p. 200
Gift of Mme Feuillatte, 1960: p. 41
Gift of Armine Ekanyan, in memory of her mother, Mme Ekanyan, 1960: p. 48
Gift of Main Rousseau Bocher, 1961: pp. 56, 82
Gift of Patricia Lopez-Willshaw, 1966: pp. 67, 98, 101, 102
Gift of Mme Margaritis, 1968: p. 42
Gift of Balenciaga, 1969: p. 117
Gift of Maurice Goudeket, 1970: p. 85
Gift of Marquise de Paris, 1971: p. 54
Gift of Elsa Schiaparelli, 1973: pp. 52, 72
Gift of Mme Bertrand de la Salle, 1973: p. 138
Gift of Mme H. de Ayala, 1974: p. 94
Gift of Michèle Rosier, 1974: p. 129
Gift of Jeanne Bourbonnais, 1975: pp. 78, 80
Gift of Chanel, 1976: p. 109
Gift of Pierre Balmain, 1979: p. 146
Gift of Musée de Romans, 1981: p. 30
Gift of Mme Arnodin Ricou, 1984: p. 97
Gift of Mme François de Saxcé, 1984: p. 50
Gift of Françoise and Éliane de Dampierre and Aymardine Matray, 1987: p. 47
Gift of Bernard Dupasquier, 1988: p. 155
Gift of Mme de Moustier, 1989: p. 63
Gift of Ezra Zilkha, 1990: p. 114
Gift of Élisabeth Bernigaud, 1990: p. 134
Gift of Sylvie Canteloube-Belliard, 1990: p. 126
Gift of Fernando Sanchez, 1993: p. 105
Gift of Guy Laroche, 1994: p. 106
Gift of Yohji Yamamoto, 1994: p. 173
Gift of Daniel Jasiak, 1994: p. 181
Gift of Yolande Amic, 1994: p. 113
Gift of Annette Laurent, 1996: p. 70
Gift of Isabel Eberstadt, 1997: p. 119
Gift of Louis Féraud, 1997: p. 143
Gift of Michèle Chatenet, 1998: p. 179
Gift of Alice Morgaine, 1998: p. 110

Gift of Martin Margiela, 1998: p. 191
Gift of Hélène David-Weill, 1998: p. 131 / 2000: pp. 122, 137, 145
Gift of the Association pour le Rayonnement de l'Œuvre de M. Yves Saint Laurent, 1998: p. 151
Gift of Mme de la Sablière, 1998: p. 121
Gift of Valentine Noble, in memory of Jacqueline Delubac, 2000: p. 185
Purchased with the patronage of Mrs. Jayne Wrightsman, 2001: p. 182 / 2002: pp. 64, 77
Gift of Givenchy, 2001: p. 192
Purchased with the contribution of the Fonds du Patrimoine and the patronage of Michel and Hélène David-Weill, 2005: p. 32
Gift of Anne-Marie Beretta, 2005: p. 160
Gift of Elaine and Harold Blatt, 2005: p. 170
Gift of Hood College, Frederick, Maryland, 2005: p. 90
Gift of Anne-Valérie Hash, 2006: p. 195
Gift of Ballet Atlantique-Régine Chopinot, 2006: p. 162
Gift of Lanvin, 2007: p. 196 / 2011: p. 210
Gift of Rochas, 2007: p. 198
Gift of Dolce & Gabbana, 2008: p. 206
Gift of Joan Lenihan, 2009: pp. 140, 149
Gift of Sonia Rykiel, 2009: p. 208
Gift of the house of Christian Lacroix - Paris, and Simon, Jérôme, Léon Falic - Bal Harbour, Florida, 2009: p. 177
Gift of Marie-Christine Clarrisse, 2009: p. 169
Gift of Brigitte Hauck, 2010: p. 157
Gift of Helmut Lang, 2010: p. 174
Gift of Bouchra Jarrar, 2010: p. 212
Gift of Véronique Branquinho, 2011: p. 204
Purchased with the support of Louis Vuitton: p. 88 / 2012: pp. 165, 217 / 2013: p. 167
Gift of the Willocq family, 2013: p. 93
Purchase Jacques Esterel: p. 132

Photographic Credits